IMAGES
of America

SAN DIEGO'S
LITTLE ITALY

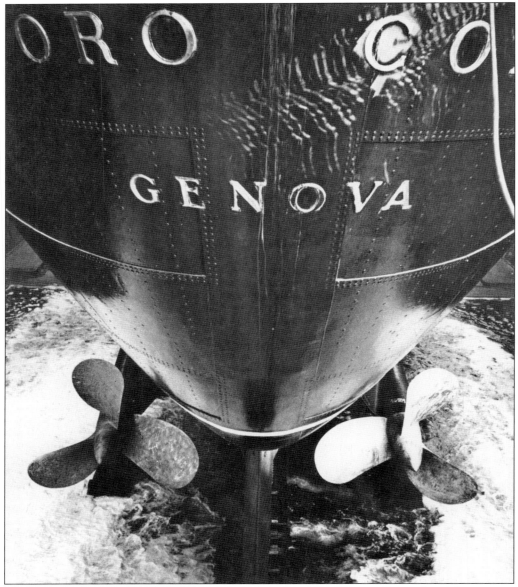

The hull of the *Cristoforo Colombo* proudly boasts the name "Genova," the place where it was built. The sister ship to the *Andrea Doria*, this vessel was among Italy's finest postwar cruise liners, bringing a later generation of Italians to San Diego from the 1950s through the 1970s. (Courtesy of the Maritime Museum of San Diego.)

ON THE COVER: Fr. Sylvester Rabagliati, who established Our Lady of the Rosary Parish in 1925 for the growing Italian immigrant population, stands at the entrance of his church in 1926. Father Rabagliati is surrounded by the children of the First Holy Communion class of 1926. (Courtesy of Our Lady of the Rosary Parish.)

IMAGES
of America

SAN DIEGO'S
LITTLE ITALY

Kimber M. Quinney, Thomas J. Cesarini,
and the Italian Historical Society of San Diego

ARCADIA
PUBLISHING

Published by Arcadia Publishing
Charleston SC, Chicago IL, Portsmouth NH, San Francisco CA

Printed in the United States of America

Library of Congress Catalog Card Number: 2007924206

For all general information contact Arcadia Publishing at:
Telephone 843-853-2070
Fax 843-853-0044
E-mail sales@arcadiapublishing.com
For customer service and orders:
Toll-Free 1-888-313-2665

Visit us on the Internet at www.arcadiapublishing.com

*We dedicate this volume to the countless Italian immigrant families
who sacrificed and labored to build a home in San Diego; to the new
generations of Italian Americans who are preserving the precious
memories of their ancestors and continuing their legacy; and to our
families for their support, love, and guidance throughout this project.*

CONTENTS

ACKNOWLEDGMENTS

We wish to enthusiastically thank all the contributors for the photographs that appear in this book. Without their invaluable help, this book would not have come to fruition. In no particular order, we thank the following individuals and families for their time and effort in helping to compile this volume: Fr. Steven Grancini and Fr. Louis Solcia, pastors of Our Lady of the Rosary Parish; Kevin Sheehan, librarian of the Maritime Museum of San Diego; Nancy Nichols and Jason Nichols of the Waterfront Bar; Ellen Guillemette of the Command Museum, Marine Corps Recruit Depot of San Diego; Emma Sofia; Mary Balistreri; Fran Marline Stephenson; Tom Cresci; Salvatore Cresci; Pete Balestrieri; Adel Weber; Anthony Ghio; Josephine "Jody" Balestrieri; Giovanna di Bona; Nigel Quinney; the Cicalo family; the Motisi family; the Cresci family; the D'Amato family; the Balistreri family; the Cesarini family; with special thanks to Our Lady of the Rosary Parish, Adel Weber, Tom Cresci, Rosemarie Motisi Brunetto, Fran Marline Stephenson, Jody Balestrieri, and Giovanna di Bona for their support of the Italian Historical Society's efforts in producing this volume. If you would like to contribute materials to the Italian Historical Society of San Diego, please contact us at italianhistory.org or 888-862-4825.

INTRODUCTION

The first Italians arriving in San Diego came in the early 1870s; it wasn't until the 1890s, however, that large numbers of immigrants began to make their way to Southern California. San Diego's "Italian colony"—as the neighborhood was referred to in its inception—was located in what was then called "Middletown," just north of downtown San Diego. The heart of the close-knit community ran along India Street, bordered by Date Street and Kettner Boulevard, and was confined by the city to the south and the ocean to the west. This protected area, which would come to be known as San Diego's "Little Italy" by the 1940s and eventually be home to more than 6,000 families, would help to define the history of San Diego.

The majority of Italians who migrated to San Diego in the early 1900s came via San Francisco, following that city's earthquake and fires of 1906. They hailed predominantly from two Italian towns—Porticello, in Sicily, and Riva Trigoso, in Liguria. As one longtime member of the community explained, "When Italians came to San Diego, they came with a purpose, with a place." Very few immigrants arrived without knowing someone—a sibling or a distant cousin—and every one of the new arrivals expected to find work.

The Italian colony was characterized as an enclosed, protected, self-sufficient space. For the majority of its existence, the Italian community in San Diego was profoundly insular. Everyone knew one another. One resident of the Italian colony aptly described the community as a "cocoon." Even as the rest of San Diego was changing, he explained, Little Italy "stubbornly adhered to its traditional way of life." Everyone spoke Italian. As a journalist for the *San Diego Union Tribune* observed in the mid-1930s, "Even the dogs speak Italian—and some won't answer if spoken to in English."

The community served to reinforce the strong ties to the mother country. But like many Italian neighborhoods across the nation in the early 20th century, San Diego's Little Italy allowed for a new kind of Italian identity—an American Italian identity—to be shaped by a variety of experiences. Like a collage, the images in this volume build upon one another to tell a story of the history and life of this Italian colony.

Chapter one, "Getting Settled: The Italian Colony Takes Shape," describes the process of immigration and settling into a way of life in San Diego. The photographs show the steps of assimilation: the immigrants arriving by ship, their Italian passports giving way to American citizenship papers and marriage certificates, and new residents getting used to community life as Italian Americans. The first chapter demonstrates how Italians managed to bring their Italian customs and traditions to San Diego and make them distinctly American.

In chapter two, the neighborhood church is highlighted as the community anchor of the Italian colony. The images in "The Foundation of Church: Our Lady of the Rosary" reveal the centrality of the church, which was founded in 1925, to the everyday lives of the residents. The parish was a pillar of support in the community, existing not merely to provide church services and Catholic rites, but to unite the community, both culturally and socially. In fact, the neighborhood continues to rely on Our Lady of the Rosary for services today; the church also promotes Italian processions, *feste* (street fairs), and infamous annual spaghetti dinners and fish frys.

"The Importance of Family: Spanning the Generations" is the focus of chapter three. Family life is at the heart of Italian culture and society; emphasis on the importance of family persisted in the San Diego neighborhood along India Street. The photographs in this chapter show a very close bond between family members, a bond that spanned generations and extended beyond the immediate family to include grandparents, uncles, aunts, and *cugini* (cousins). Family occasions were often formal—to celebrate weddings or Easter Sunday—for example. But more often, the images convey spontaneous family gatherings as a part of daily life for the Italian colony.

The economic foundation for San Diego's Little Italy from its inception until the late 1940s was the fishing industry. Chapter four, "Sea Change: The Fishing Industry," surveys the many ways in which fishing for sardines and tuna—and related industries, such as canneries, boatbuilding, and seafood retail and restaurants—shaped the Italian neighborhood. For most residents of the Italian colony, fishing defined their lives. The names of the boats (*silene*), the nets (*paranzelle*), and the processes of maintaining both were all borrowed from Italian methods. In this chapter, different families relate the skill and expertise required for their grandfathers to build the boats, for their grandmothers to make and mend the large nets, for their fathers to manage the factory floors of the cannery, or for their mothers to become entrepreneurs in the seafood industry.

The fifth and final chapter, "Slice of Life: Pastimes and Social Structures," offers a visual mosaic describing daily social life and pastimes in the colony. Images of the local schools and children showcase adolescent boys' dice clubs and girls' glee clubs, church pageants and processions, annual nightclub parties, neighborhood shops, and downtown shopping. And then, there were the family dinners. Weekly Sunday dinners were prepared and eaten at home, but they were also often prepared to carry out—to the beach at La Jolla Shores, or on a blanket in Balboa Park, or on a fishing boat headed for Coronado Island. Wherever the meals were eaten, "everything—including the kitchen sink!"—as one community member explained, was packed up for the meal and enjoyed by all members of the family.

Although the neighborhood has changed dramatically since its origin in the early 20th century, the heart and soul of India Street remains Italian, albeit in a revitalized form. One can visit San Diego's Little Italy today and enjoy gelato and cappuccino in outdoor cafés, as well as participate in the annual Italian *feste*. Today's Little Italy invites all visitors to San Diego to share in and celebrate the Italian heritage of the city. The implicit hope in this volume is that the visual history revealed echoes that invitation. The explicit goal is to inspire a commitment to the preservation of the city's Italian cultural identity.

One

GETTING SETTLED
THE ITALIAN COLONY TAKES SHAPE

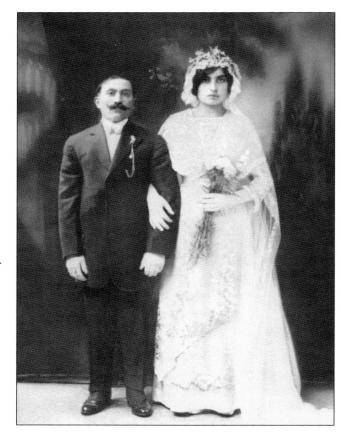

Giuseppe Cicalo and Rosa Raucci are photographed at their wedding in 1916. The nuptials took place in Bridgeport, Connecticut, shortly after the couple immigrated to America. When the Cicalos moved to San Diego, they originally lived in the house adjacent to Our Lady of the Rosary Parish in the heart of the Italian colony; they then relocated to Barrio Logan. (Courtesy of the Cicalo family.)

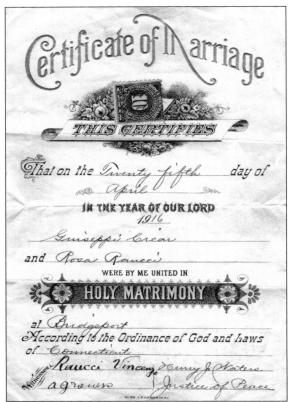

Documents, or "papers," such as this certificate of marriage between Giuseppe Cicalo and Rosa Raucci, were essential to immigrant families. Possessing U.S. legal documents provided opportunities for employment and access to public schooling. Note that the authorities processing the certificate have misspelled Giuseppe's name. Such translation errors were frequently reported among Italians migrating to the United States. (Courtesy of the Cicalo family.)

The Amelia Carneglia–Federico Marline wedding was celebrated at St. Joseph's Cathedral on Third Avenue in 1917. Shortly after arriving to San Diego, Carneglia's father, Angelo Carneglia, purchased property on Kettner Boulevard and Laurel Street, which he later developed. Property was a commodity that was unavailable to the vast majority of Italians in Italy; in America, however, land would open doors for immigrants. (Courtesy of Fran Marline Stephenson.)

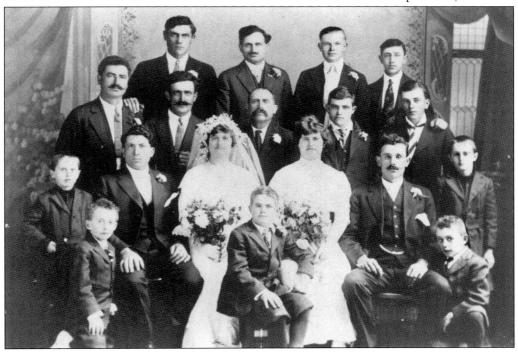

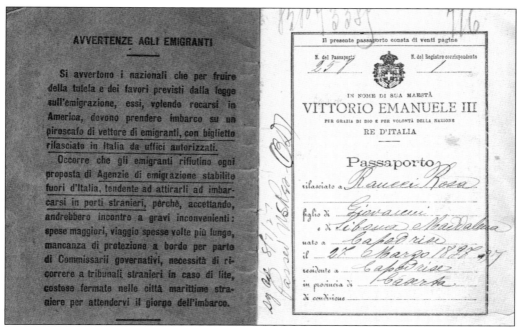

Rosa Raucci's 1927 Italian passport is representative of the story of migration for the earliest residents of the Italian colony. The Italian passport was necessary as it obviously provided entry to the United States. Within a decade, however, Raucci—and many others like her—would attend night school to learn English and earn her citizenship certificate. She would exchange her Italian passport for an American passport and U.S. citizenship in 1937. (Courtesy of the Cicalo family.)

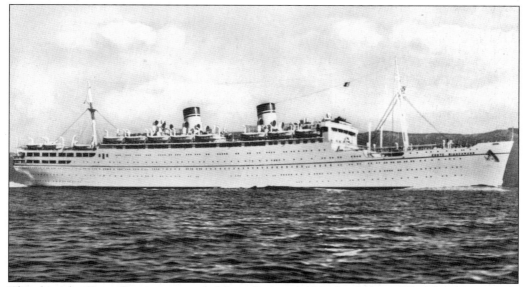

This ship, the *Conte Biancamano*, sailed from Genoa and Naples, Italy, to Ellis Island, New York. This image is from the 1940s. The ship was acquired by Italia Line in 1932 and continued to sail until 1960. During World War II, in 1941, the ship was seized by the U.S. government and converted to a naval ship. (Courtesy of the Balistreri family.)

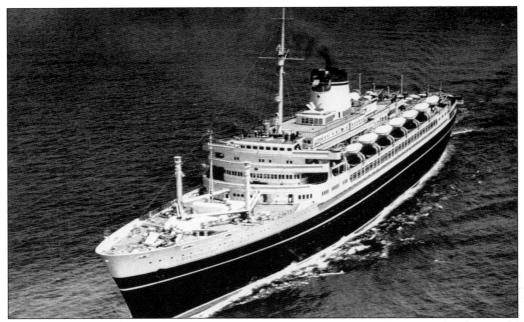

The *Cristoforo Colombo* brought many Italian immigrants to the United States. The ship would often take two weeks to cross the Atlantic Ocean. (Courtesy of the Maritime Museum of San Diego.)

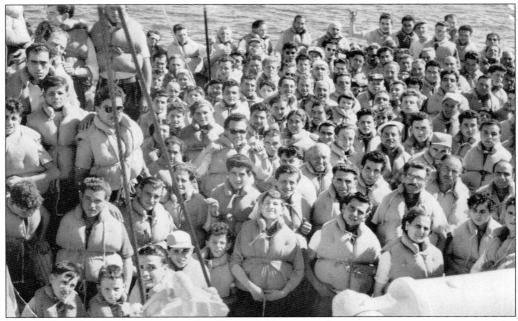

Tony Balistreri, an immigrant to San Diego, was among the passengers crossing over to the United States on the Italian liner *Andrea Doria* in 1955. Balistreri crossed over on the voyage prior to the one in 1956 in which the *Andrea Doria* collided with the *Stockholm* and sank. The *Andrea Doria* was reputed to be among the most beautiful ships of the postwar era. (Courtesy of the Balistreri family.)

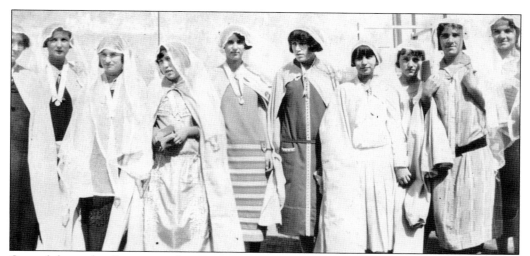

One of the early all-women religious societies of Our Lady of the Rosary Parish is seen here c. 1930. The women of the parish played an important role in organizing events and activities for the parishioners. (Courtesy of Our Lady of the Rosary Parish.)

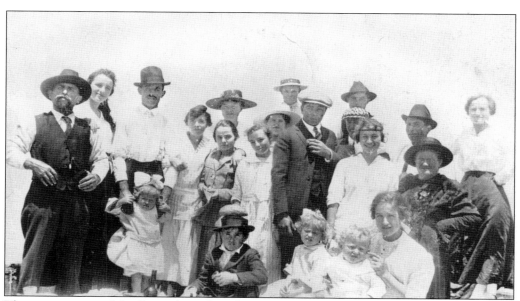

Three generations of the Carneglia and Marline families in 1917 are portrayed here at San Diego's waterfront. Bordering the Italian colony on the west, the waterfront was walking distance to the heart of the community along India Street. In this photograph, the families have gathered for an afternoon of strolling along the harbor, a common Italian tradition they brought from the coastal areas of Italy. (Courtesy of Fran Marline Stephenson.)

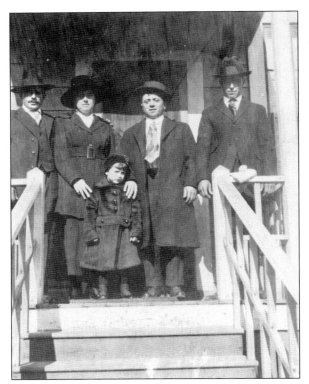

A prominent Italian colony patriarch, Michael Ghio, stands at the center, surrounded by relatives from Italy as they prepare to leave for a walk to church. The family is standing on the front porch of their home on Columbia Street c. 1925. Ghio arrived in San Diego via San Francisco, as was the case for many Italians in the colony. He rose to local prominence in the fishing industry. (Courtesy of Adel Weber.)

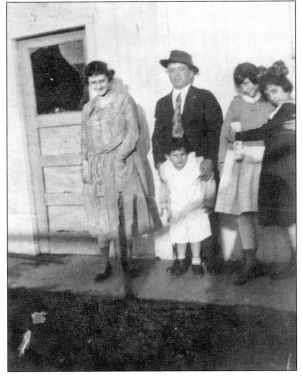

The Ghio family is joined by friends in their backyard c. 1927. A typical practice of the residents living in the Italian colony—also borrowed from their Italian heritage—was to gather with family and friends at their homes for no particular occasion. (Courtesy of Adel Weber.)

In this whimsical image that so wonderfully typifies the era and way of life in the early days of the Italian colony, Cecilia Ghio appears on her back porch on Columbia Street in 1918. An important transition for young women, especially, was from Italian gender roles to newly defined Italian American gender roles, in which women took on further responsibilities than traditional homemaking such as in work or at school. (Courtesy of Adel Weber.)

Catherine Bregante Ghio (known as "Mama Ghio") stands in front of her home in 1931. Ghio successfully managed to adapt to her new role as head of the household after the untimely death of her husband, Michael. She earned a reputation as a prominent member of the Italian community in the 1930s and went on to establish the hugely successful Anthony's Fish Grotto seafood restaurants in the 1940s. (Courtesy of Adel Weber.)

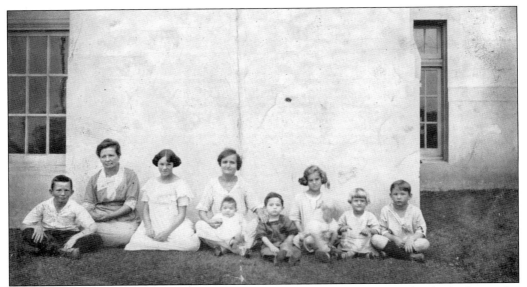

In 1923, Ghio, Zolezzi, and Marline children sit in front of Washington School, which was the elementary school attended by the Italian children from 1913 to 1960. At Washington School, a new generation of Italian American children was acquiring the necessary tools to settle into life in America. (Courtesy of Fran Marline Stephenson.)

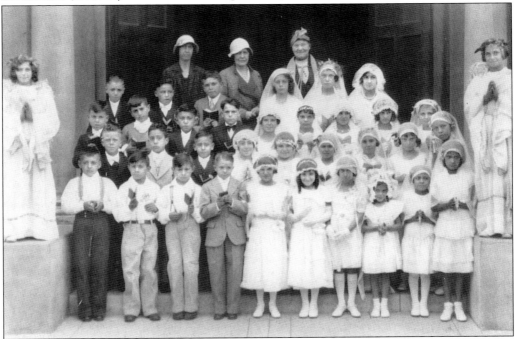

The new generation of Italian Americans in San Diego was educated at Washington School—and was thus schooled in American practices—but also maintained a close connection to the Italian heritage. The Italian youth continued to speak and write the Italian language, and they also kept traditional and ceremonial rites of passage in the Italian Catholic Church, as depicted in this 1929 First Holy Communion photograph. (Courtesy of the Cresci family.)

An early church youth group congregates for a quick snapshot *c.* 1930 outside a home in the neighborhood. The youth members in the parish were very active participants in plays, pageants, and annual celebrations, a commitment the parish youth of today continues. (Courtesy of Our Lady of the Rosary Parish.)

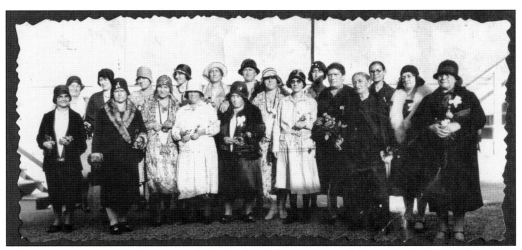

These women represent the original Our Lady of the Rosary Sodality in 1924. The sodality was one of many religious groups dedicated to fostering a sense of pride in the community and in the church. (Courtesy of Our Lady of the Rosary Parish.)

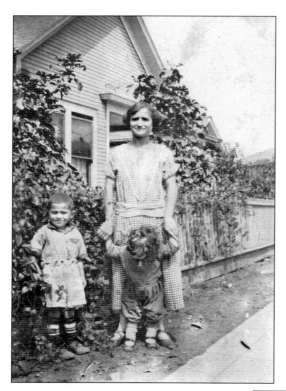

The young Marline family enjoying the outdoors at their home on India Street exemplifies the simplicity of life in the early Italian colony. The image, taken in 1924, shows Joe Marline, his mother Amelia, and his sister Fran "Frenchie" alongside the fence of their home, which still stands on India Street today. Graced by a vegetable garden in the back, the house itself was typical of the residences in the neighborhood. (Courtesy of Fran Marline Stephenson.)

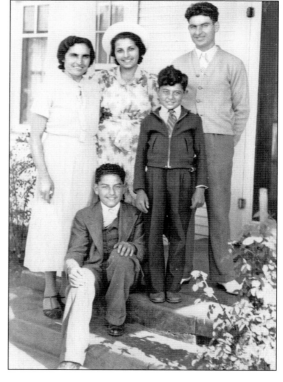

This image of the Cicalo family, taken on Easter Sunday at their Barrio Logan home in 1934, tells a slightly different story of the Italian experience in San Diego. The Cicalo family moved to Barrio Logan, just south of the Italian colony, to be closer to the fishing canneries, as virtually all members of the family entered the canneries for employment. (Courtesy of the Cicalo family.)

Taken at the back of the Marline home on India and Date Streets in 1929, this image captures children in their Sunday best as they celebrate Fran Marline's confirmation. The children are standing among cabbage leaves, carrot tops, and nasturtiums along the fence in the back garden. From left to right are Joe Marline, Fran Marline, Steve Zolezzi, and Eleanor Zolezzi. (Courtesy of Fran Marline Stephenson.)

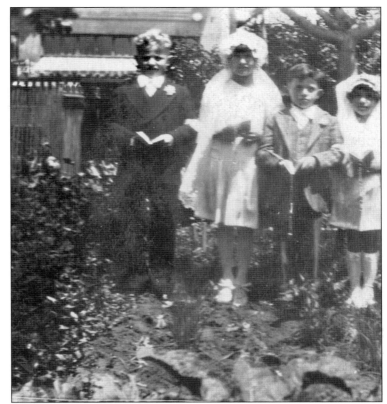

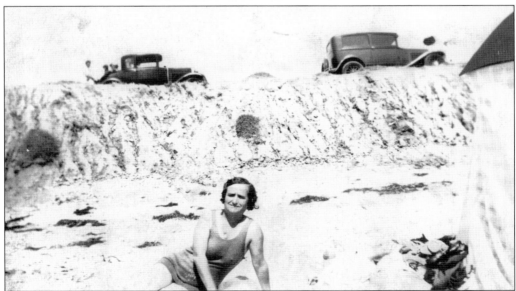

A frequent pastime for residents of the early Italian colony, and even for those who remained in the neighborhood after World War II, was to head to the beach. This photograph of Amelia Marline was taken at La Jolla Shores in 1933. Beachcombers would park their cars along the cliffs and carry picnic baskets down to the shore. (Courtesy of Fran Marline Stephenson.)

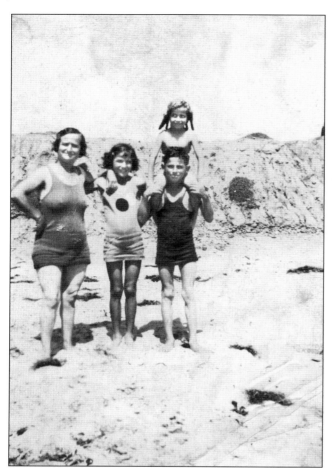

From left to right, Amelia, Fran, Ortencia "Toodles," and Joe Marline are at La Jolla Shores in 1933. Frequent family outings to the beach are recalled fondly by residents of the Italian colony. The natural beauty of San Diego provided an inexpensive retreat for the residents of the community wanting to take a break from work and the densely populated neighborhood. (Courtesy of Fran Marline Stephenson.)

Eileen Ghio is poised on the shoulders of Michael Ghio (left) and Fred Bregante at Coronado Beach around 1916. Note the Coronado boardwalk in the background. Coronado was another popular destination for Italian families on the weekends. Many of the Italian families owned their own fishing boats and thus had the capacity to carry the entire family as well as friends across the bay to the island for an afternoon excursion. (Courtesy of Adel Weber.)

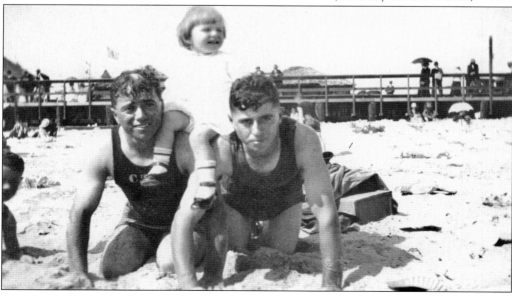

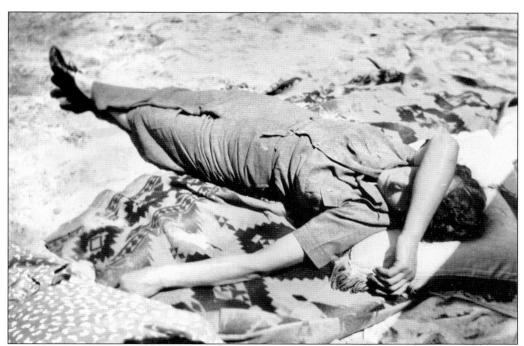

Catherine Bregante Ghio catches a moment of rest in Ocean Beach in 1925. Among those beaches most frequented by the Italian colony residents were La Jolla Shores, Coronado Beach, Ocean Beach, and Mission Beach. (Courtesy of Adel Weber.)

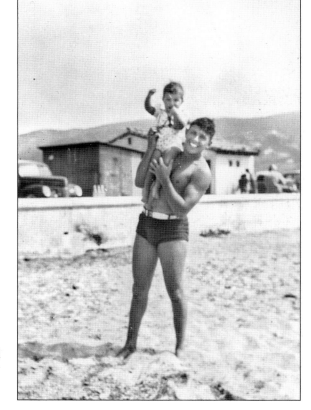

Even as the Italian colony grew, the beach continued to provide respite for its residents. In this photograph, Tod Ghio holds his niece Beverly Weber in Ocean Beach in 1943. As did the majority of young men from the neighborhood, Ghio served in World War II. (Courtesy of Adel Weber.)

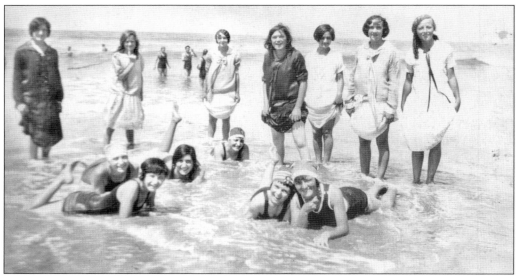

Young women bask in a day of fun around 1920. As their brothers, fathers, and husbands were most likely out to sea on the fishing vessels, the women, too, enjoyed being in the water on this afternoon and many others. (Courtesy of Our Lady of the Rosary Parish.)

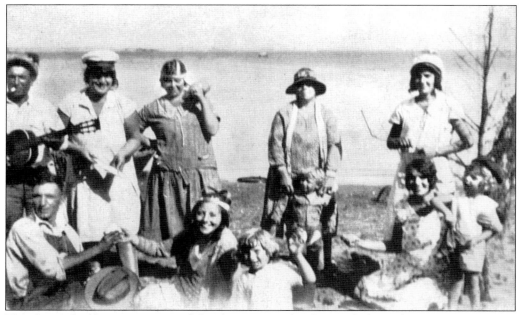

The Cresci family enjoys a typical family picnic at the Coronado bay side area. A prominent family in the colony, the Crescis owned property in the Italian neighborhood, and the family continues to manage a row of boutiques, known as the Fir Street Cottages, in today's revitalized neighborhood. (Courtesy of the Cresci family.)

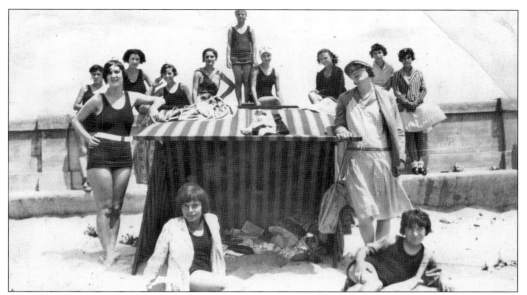

A group of women enjoys the beach under a striped cabana c. 1920. This was an opportunity for these women to take time away from the daily commitments of the colony's domestic life and requisite responsibilities. (Courtesy of Our Lady of the Rosary Parish.)

Francis Cresci poses in front of the Coronado boathouse, c. 1924, across from the Hotel Del Coronado. The "Del," as it is known to local San Diegans, is a historic landmark on Coronado Island. The boathouse rented sailboats and offered instruction on water activities for the entire family to enjoy. (Courtesy of the Cresci family.)

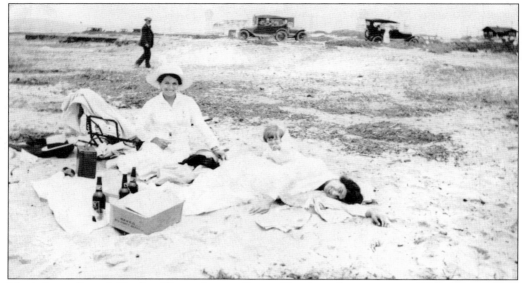

Mary (seated) and Cecilia Ghio relax in Ocean Beach with a picnic *c.* 1920. (Courtesy of Adel Weber.)

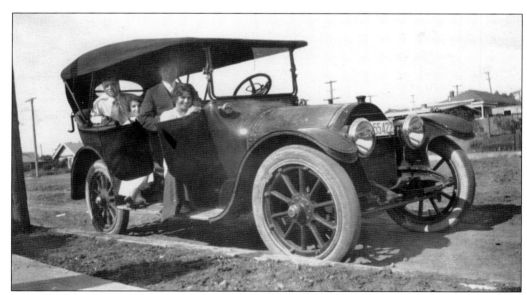

Ghio family members sit in the family car *c.* 1920. The purchase of the first family car is described by many residents as profoundly affecting their way of life, as they were then able to take short trips outside of the neighborhood to various locations beyond walking or trolley distance. (Courtesy of Adel Weber.)

Catherine Bregante Ghio is seen standing alongside the family Cadillac c. 1930. Quite often, everyone would pile into the car and head to Sheets Ice Cream shop on Twelfth and C Streets for pistachio ice cream, a family favorite. (Courtesy of Adel Weber.)

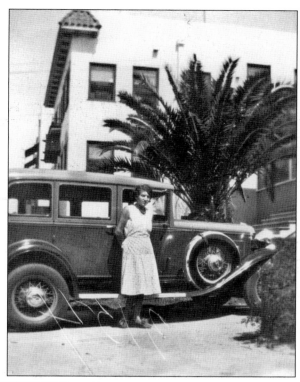

Lino Bregante, cousin of Catherine Bregante, stands proudly beside his new Cadillac convertible in front of the Ghio home on Union Street. (Courtesy of Adel Weber.)

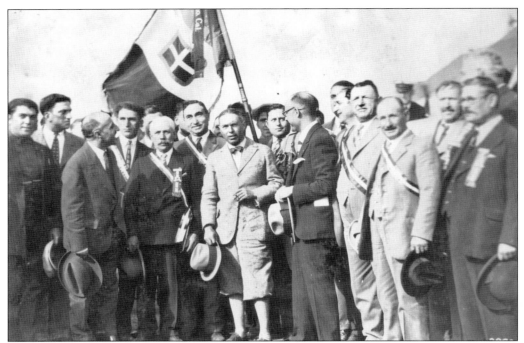

Members of the Knights of Columbus fraternity pose in 1924 for a picture with Francesco Di Pinedo, the famed Italian aviator, who stands in the center wearing knickers. Di Pinedo was the first foreign aviator to fly to the United States and has been dubbed the "Italian Lindbergh." (Courtesy of Our Lady of the Rosary Parish.)

Children of Italian parents growing up in the community spoke Italian, yet their parents' desire for them to learn correct Italian brought about the first Italian language school in the early 1930s. Students met every week after their regular classes at Washington School with their teacher, Anna Motisi, who also served as director of the Casa Italiana in Balboa Park, shown here. The House of Italy provided many civic and social activities for the Italian community. (Courtesy of Our Lady of the Rosary Parish.)

Two

THE FOUNDATION
OF CHURCH
OUR LADY OF THE ROSARY

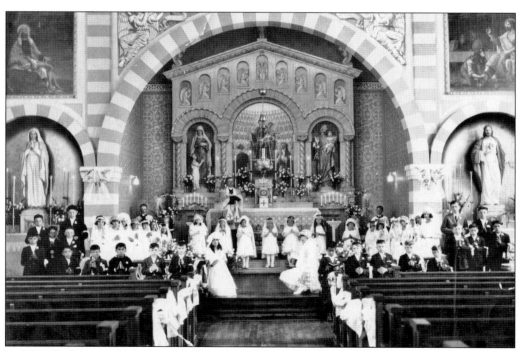

In 1925, Fr. Sylvester Rabagliati, the founding father of Our Lady of the Rosary Parish, stands on the altar overlooking children posing for a photograph to capture their First Holy Communion celebration. The church was, and still remains, a marvelous aesthetic achievement in the community for its art and architecture. (Courtesy of Our Lady of the Rosary Parish.)

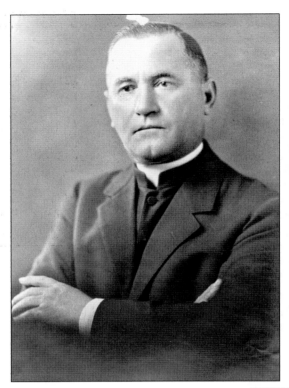

Fr. Sylvester Rabagliati came to San Diego and founded Our Lady of the Rosary Parish in 1925 in response to a need for a new church for the rapidly expanding community. Father Rabagliati built the church on the corner of State and Date Streets, and the church has remained an anchor for the Italian community for more than 80 years. (Courtesy of Our Lady of the Rosary Parish.)

After the death of Father Rabagliati, Fr. Vito Pilolla was chosen in 1935 to replace him and carry on the vital work Rabagliati had started. Father Pilolla would have to assume the debt incurred for the establishment of the church, but the community quickly responded to Father Pilolla's request for financial help. The local fishermen banded together and agreed to contribute a portion of their fishing income to pay for the church debt. (Courtesy of Our Lady of the Rosary Parish.)

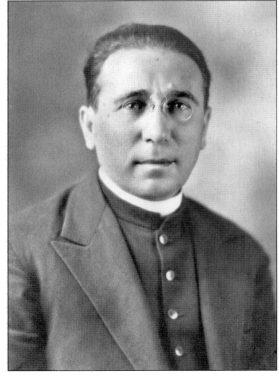

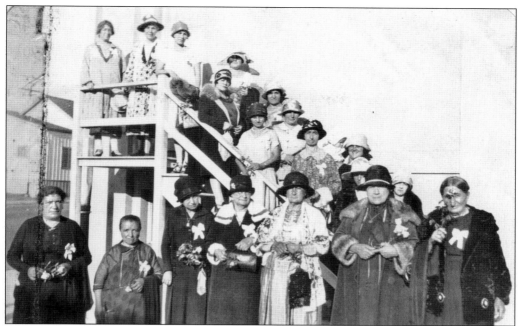

This 1926 photograph of the Our Lady of the Rosary Sodality group captures one of the first of the many societies and organizations that arose from Our Lady of the Rosary. (Courtesy of Our Lady of the Rosary Parish.)

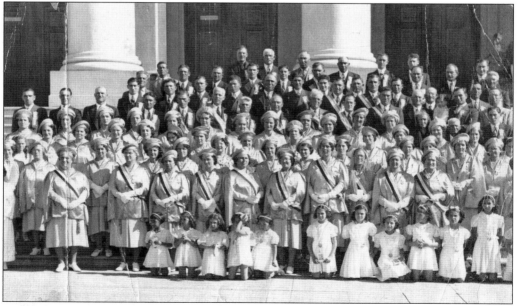

Standing in front of Washington School on State Street, the 1936 Madonna del Lume Society displays its prominence in sheer number alone. The society continues to this day, as does its annual procession to the wharf, in which the society members and the community accompany the statue of Our Lady of Light. (Courtesy of Our Lady of the Rosary Parish.)

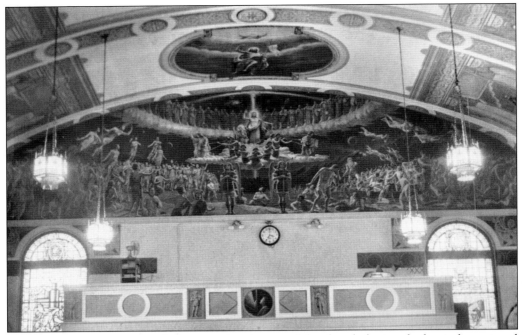

In this contemporary image, the art mural at the rear of the church depicts the last judgment and is the vision of famed Venetian artist Fausto Tasca. Tasca was commissioned by Father Rabagliati to create the art for the church. If one looks closely, the image of Father Rabagliati is visible in the lower left corner. (Courtesy of Our Lady of the Rosary Parish.)

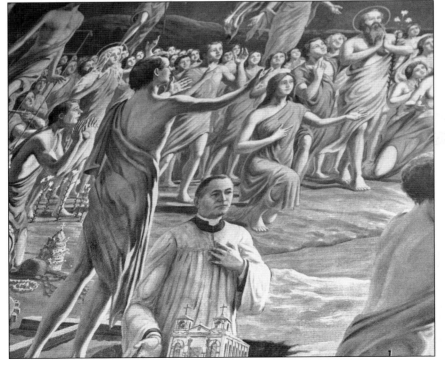

The image of Father Rabagliati in the Tasca mural is very prominent if one knows where to look. Father Rabagliati, such an important figure for the Italian colony, has thus been memorialized within the walls of the church he created. (Courtesy of Our Lady of the Rosary Parish.)

Societies of Our Lady of the Rosary Parish to honor the Madonna abounded. In 1926, the Society of the Holy Rosary banner was raised to prominence. Many of the societies were founded by the women of the parish, and the women continued for decades to be leaders of the church, especially in its civic and cultural aspects. (Courtesy of Our Lady of the Rosary Parish.)

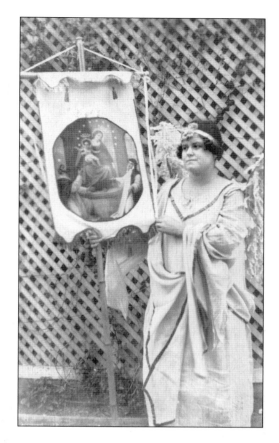

Our Lady of the Rosary has always encouraged children's participation and has strived to reach out to its youth. In this image, Mary Canepa is standing next to a child, preparing for the Christmas pageant of 1928. (Courtesy of Our Lady of the Rosary Parish.)

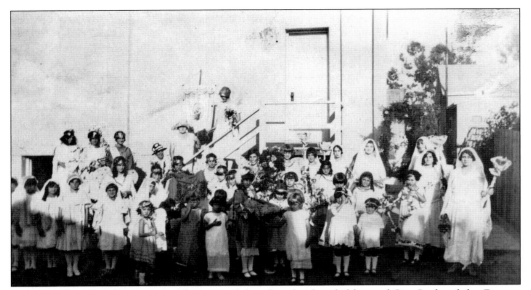

Stopping for a quick picture at the rear of the church, the children of Our Lady of the Rosary Parish are dressed for a celebration of their church, c. 1928. (Courtesy of Our Lady of the Rosary Parish.)

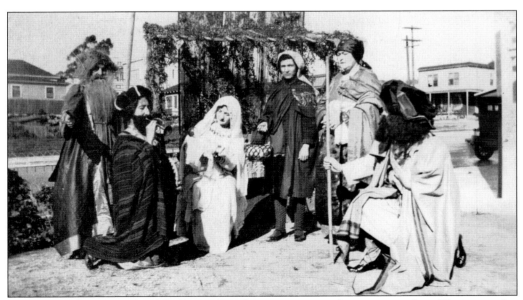

Members of the Our Lady of the Rosary Parish congregation rehearse scenes for a Christmas play around 1928. (Courtesy of Our Lady of the Rosary Parish.)

Augustina Zolezzi was the president in 1925 of the first Our Lady of the Rosary Sodality. Zolezzi stands in front of the sodality banner. She remained a prominent figure in the church for many years and reflects the importance of women in the care of the parish. (Courtesy of Our Lady of the Rosary Parish.)

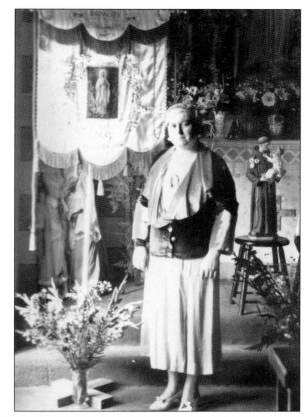

Rosa Cicalo (standing at center) embraces her friends at her home, directly adjacent to Our Lady of the Rosary Parish. The trio is celebrating a saint's feast in 1940. This house, fairly well-known in the community, was for years purported to be haunted. (Courtesy of the Cicalo family.)

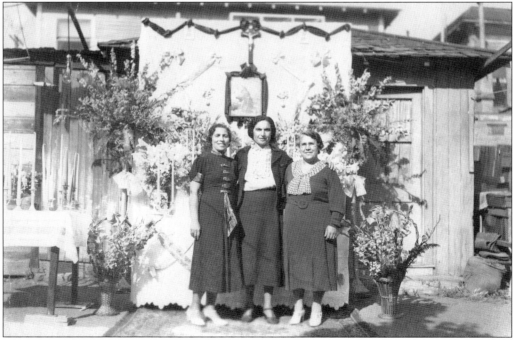

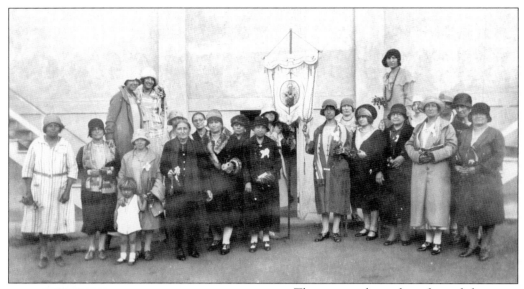

The women shown here formed the original Sodality of Our Lady of the Rosary Parish in 1925, as they hold their society's banner with pride. Members of these societies often spanned the generations. (Courtesy of Our Lady of the Rosary Parish.)

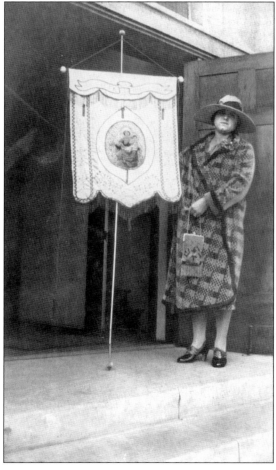

The banner in this *c.* 1926 image is for another prominent group, the Society of the Holy Rosary. (Courtesy of Our Lady of the Rosary Parish.)

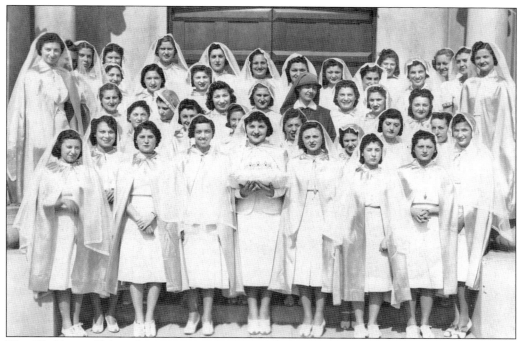

The Children of Mary Society was one of several church clubs from Our Lady of the Rosary Parish. This image is from 1937. Rose Giolzetti, a prominent member of the church congregation and active participant in the societies, is in the third row, first on the right. (Courtesy of the Cresci family.)

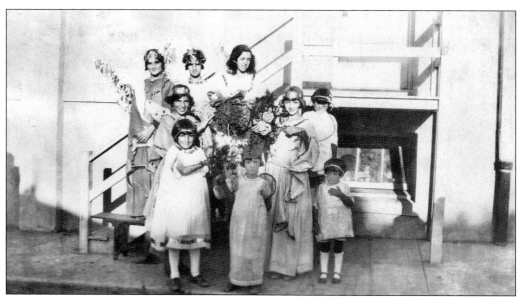

This c. 1928 photograph captures the important role of the children of Our Lady of the Rosary Parish as they are photographed behind the church. They are dressed for a church pageant, a frequent event in the parish roster of activities for the youth. (Courtesy of Our Lady of the Rosary Parish.)

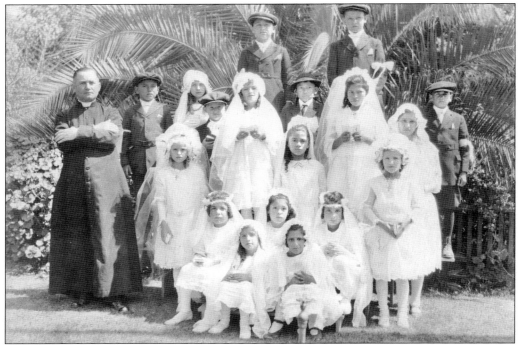

Father Rabagliati stands proudly as the children celebrate their First Holy Communion in 1922. This photograph was taken a few years before the establishment of Our Lady of the Rosary Parish in 1925. Yet Father Rabagliati had already begun to lay the foundation for the church at the time of this image. A small home on the corner of Columbia and Date Streets served as a chapel for several years until the new church could be built. The land belonged to the Madalena family. (Courtesy of Our Lady of the Rosary Parish.)

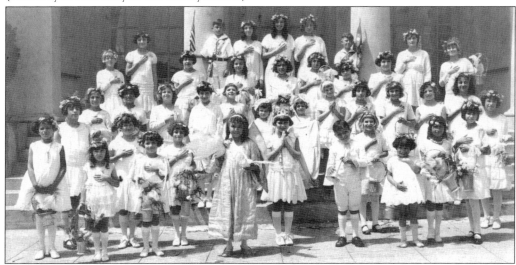

The younger members of the Our Lady of the Rosary Parish congregation gather in front of Washington School, just up the street from the church, around 1931. The school often provided a wonderful backdrop for photographs taken in the community, and it was a prominent part of the Italian colony. (Courtesy of Our Lady of the Rosary Parish.)

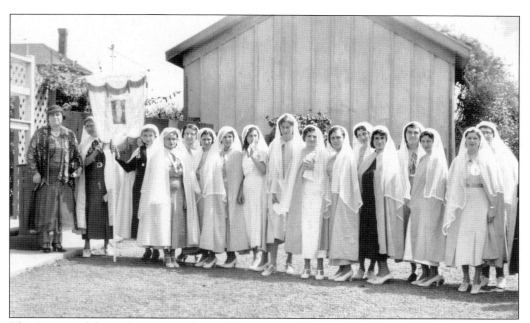

The Society of the Holy Rosary is honored with a photo opportunity in the rear of the parish in 1935. (Courtesy of Our Lady of the Rosary Parish.)

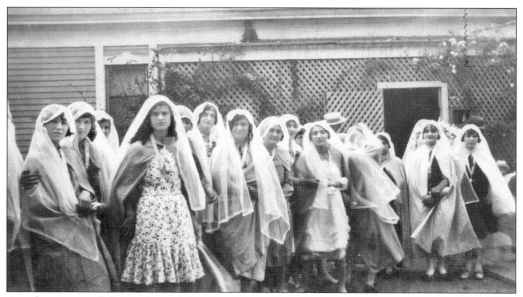

Another image of the Society of the Santo Rosario, or the Holy Rosary, in 1935 also highlights the regalia tradition of the society members. (Courtesy of Our Lady of the Rosary Parish.)

Members of Our Lady of the Rosary Parish, *c.* 1930, don their hats with pride. The church societies served as much of a social function as they did a religious one. (Courtesy of Our Lady of the Rosary Parish.)

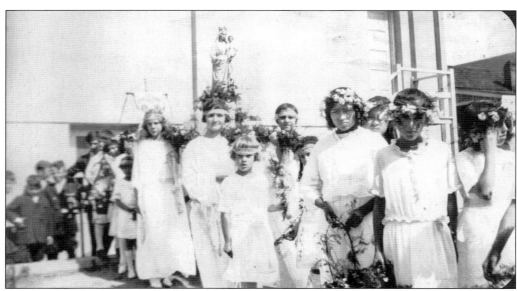

Children are pictured celebrating an event in honor of the Madonna around 1925. (Courtesy of Our Lady of the Rosary Parish.)

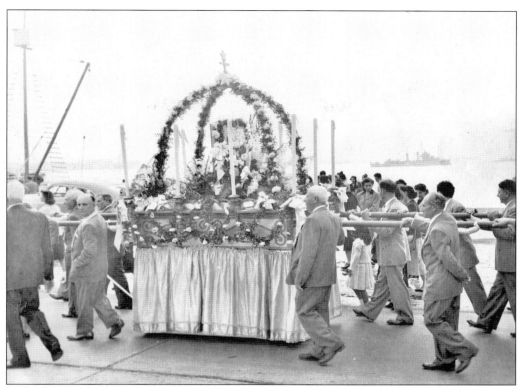

In the late 1930s, Sicilian immigrants formed the Madonna del Lume Society, or Our Lady of Light. The celebratory procession, perhaps the most important aspect of the annual celebration in honor of the Madonna, would take the congregation, accompanying a statue of the Madonna, down to the wharf. (Courtesy of Our Lady of the Rosary Parish.)

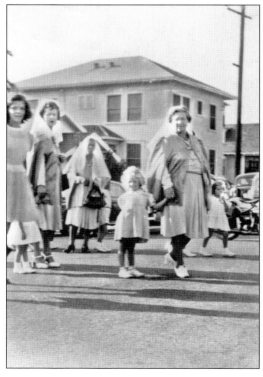

Antoinette Herrera holds the hand of her grandmother, Nina Orlando, as they walk in the procession for the Our Lady of the Rosary Parish Madonna del Lume Society in 1947. The procession is celebrated annually in October by the fishermen of Porticello, Sicily, to thank the Madonna for a bountiful harvest and safe fishing trips. (Courtesy of Mary Balistreri.)

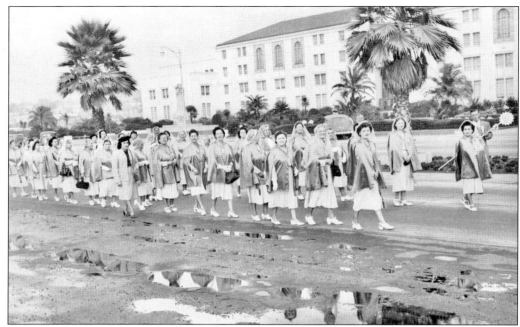

Processions were of vital importance to the parishioners, and they remain so to this day. In this c. 1945 image, the San Diego County Administration building is prominent in the background. The procession is heading toward the wharf, as was customary, and the event would culminate in a return to the church and celebratory activities. (Courtesy of Our Lady of the Rosary Parish.)

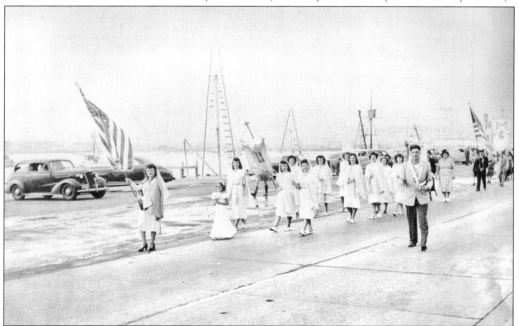

In this c. 1942 procession at the San Diego wharf, church members proudly carry the American flag, at once showing their religious conviction and newly acquired sense of American patriotism. (Courtesy of Our Lady of the Rosary Parish.)

A contemporary photograph of the annual processions held at Our Lady of the Rosary Parish reflects the long-standing traditions the Italians brought with them. Processions continue to form the primary events that distinguish the parish in the community. (Courtesy of the D'Amato family.)

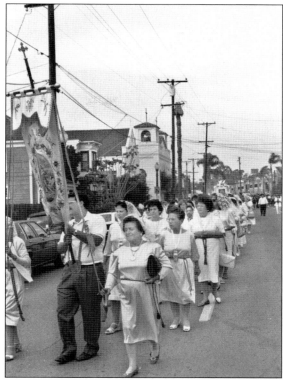

The Madonna del Lume Society stops its journey to the San Diego wharf and back to the church for a quick photograph around 1940. (Courtesy of Our Lady of the Rosary Parish.)

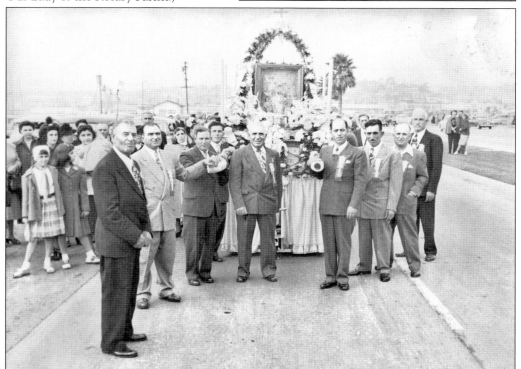

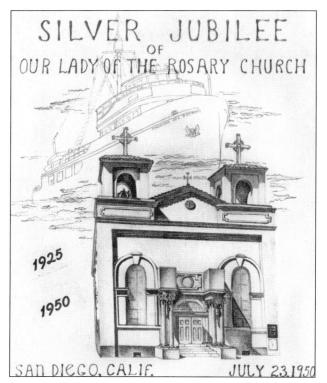

In 1950, Our Lady of the Rosary Parish celebrated its silver jubilee. This is the front cover of the program for the festivities. During this time, the church was under the guidance of Msgr. Joseph Trivisonno, another important figure in the church's history. (Courtesy of Our Lady of the Rosary Parish.)

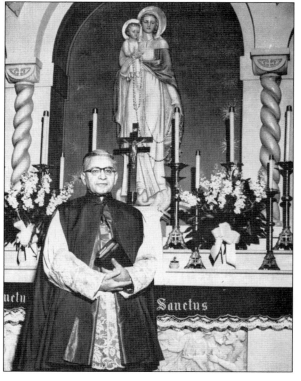

Msgr. Joseph Trivisonno stands in front of the altar at Our Lady of the Rosary Parish in 1956. Monsignor Trivisonno served as the parish pastor for 20 years in the 1950s and 1960s, and he was the originator of San Diego's Italian Fair, established in 1954. (Courtesy of Our Lady of the Rosary Parish.)

A trio of women represents the Madonna del Lume Society c. 1938. Other prominent societies in the church included the Madonna Addolorata (Our Lady of Sorrows), the Madonna del Paradiso, and the St. Joseph Society—all three of which continue today. (Courtesy of Our Lady of the Rosary Parish.)

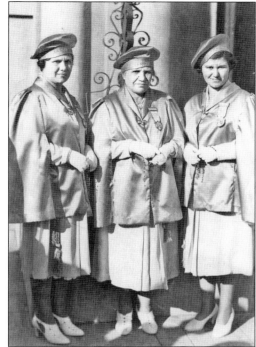

This more contemporary photograph of a women's parish society conveys how the traditions have carried on throughout the decades and continue to be a vital component to Italian life in San Diego. (Courtesy of Our Lady of the Rosary Parish.)

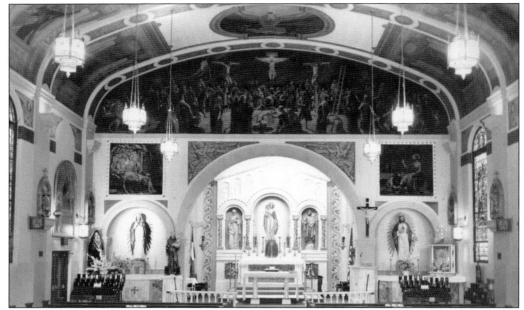

This contemporary image of the interior of Our Lady of the Rosary nicely encapsulates the scope of the artwork by Fausto Tasca. The statues were the work of famed sculptor Carlos Romanelli. Because of its uniqueness and the commitment of its parishioners, Our Lady of the Rosary Parish is considered a jewel in San Diego. (Courtesy of Our Lady of the Rosary Parish.)

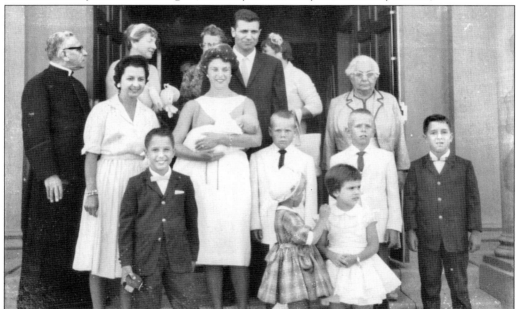

Ghio family members exit the church after a christening *c.* 1950. Through the years, the parish has hosted a great number of communions, confirmations, and baptismal, matrimonial, and funeral proceedings. And even though most Italian families have moved away from what was the original neighborhood, they still return to the church weekly and for any special occasions or events. (Courtesy of Adel Weber.)

Three

THE IMPORTANCE
OF FAMILY
SPANNING THE GENERATIONS

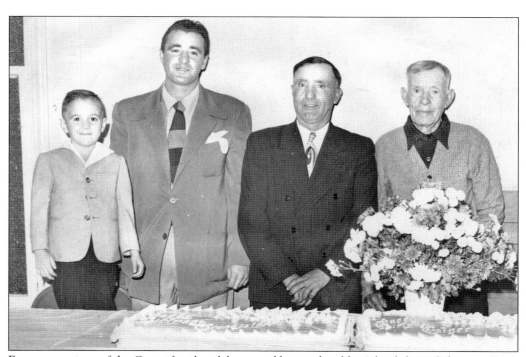

Four generations of the Cresci family celebrate and honor the eldest's birthday—Salvatore. From left to right are Tom; Salvatore "Sal"; Gaetano "Tom"; and the eldest, Salvatore. In keeping with the Italian tradition, young Tom, as a firstborn male, takes his name after his paternal grandfather. (Courtesy of Tom Cresci.)

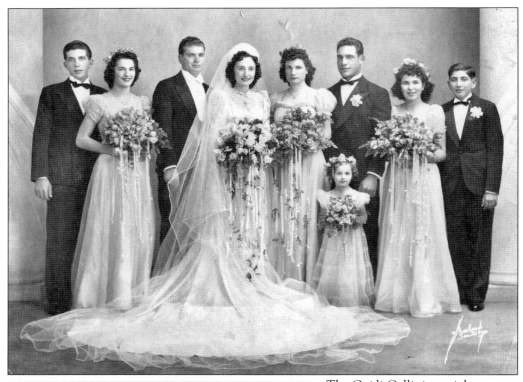

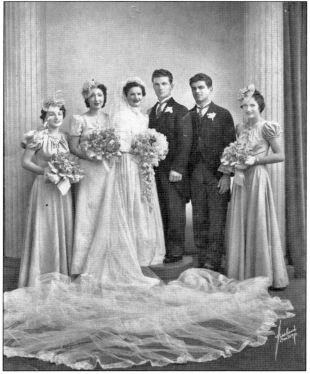

The Guidi-Collini nuptial ceremony offers a glimpse of a typical Italian wedding celebration. The wedding party poses formally at Our Lady of the Rosary Parish in 1938. (Courtesy of Fran Marline Stephenson.)

Taking place in 1940, the Rippo-Zolezzi wedding provides another view of the community embracing its traditions. The marriage also took place at Our Lady of the Rosary Parish. Both families were prominent in the local fishing and retail industries. (Courtesy of Fran Marline Stephenson.)

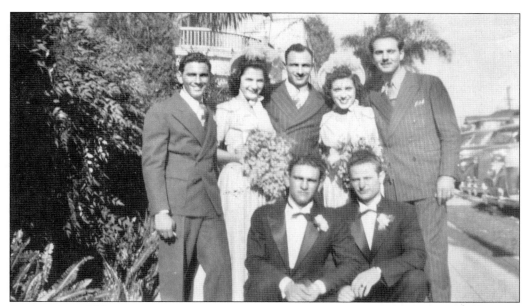

As Angelo and Margaret Zolezzi's wedding celebration in 1942 suggests, many aspects of the traditional Italian wedding continued well into the modern era. The wedding party poses for a casual photograph in front of the bride's home on Union Street. Fran Marline Stephenson holds the flowers on the left. (Courtesy of Fran Marline Stephenson.)

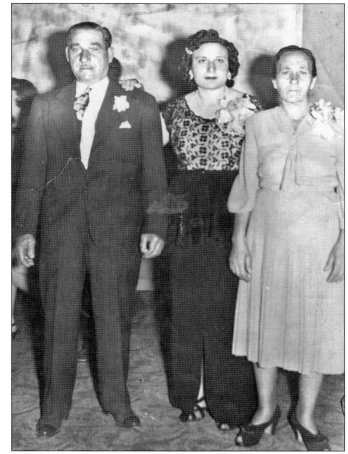

Josephine Piraino stands between her parents, Joseph and Maria Sardina, in 1947 on the occasion of her brother's wedding. Piraino's father and husband were both prominent in San Diego's fishing industry. (Courtesy of the D'Amato family.)

On Easter Sunday in 1940, Catherine Ghio pauses for a moment to take this photograph with her two sons, Tod (left) and Anthony. (Courtesy of Adel Weber.)

Fran Stephenson (right) celebrates her confirmation day in 1935 with her sister, Toodles. The siblings stand in front of their aunt Angela Zolezzi's home on India Street, across from where Filippi's Pizza Grotto is now located. (Courtesy of Fran Marline Stephenson.)

48

The Ghio family (from left to right, Anthony, Adel, Catherine, Michael, and Tod) celebrates Easter Sunday in typical fashion—by taking an excursion to Balboa Park. The family (as with many others in the community) would often go to Balboa Park, not only on holidays but for birthday parties, picnics, and leisurely strolls. (Courtesy of Adel Weber.)

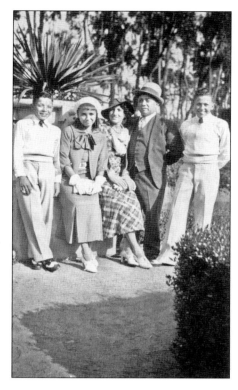

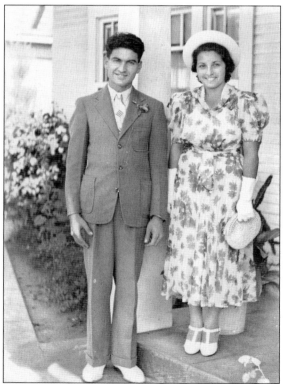

Catherine Cicalo and her elder brother, Fred, seen here *c.* 1934, stand outside their home in Barrio Logan. (Courtesy of the Cicalo family.)

The back porch of the Marline home on India and Date Streets shows the narrow alleyway between residences in the neighborhood around 1938. The closely built homes echo the close family ties of this tightly knit community. (Courtesy of Fran Marline Stephenson.)

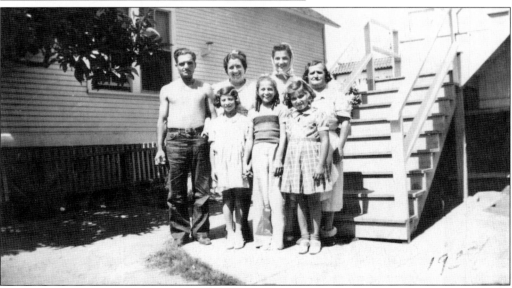

Also in 1938, the Marline family entertains its neighbors outside the home. The Marline residence was one where everyone could always find the Italian hospitality (and food) so entrenched in these immigrants' way of life. (Courtesy of Fran Marline Stephenson.)

Rose Giolzetti Cresci is on the left, standing in front of her home with a friend on Fir Street, c. 1928. The girls are carrying Easter baskets, getting ready for the big Italian Easter feast. Today Cresci and her family own and operate the Fir Street Cottages, a row of boutiques on a side street of the main thoroughfare, India Street. (Courtesy of the Cresci family.)

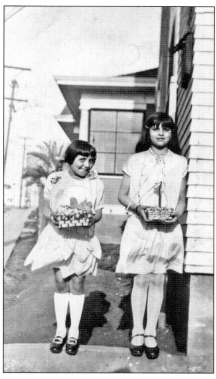

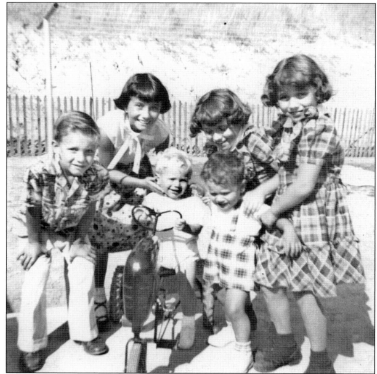

The Weber children play with their cousins in 1940 in front of their aunt's home. Their grandmother, Catherine Ghio, became a famed restaurateur. (Courtesy of Adel Weber.)

In this formal portrait, *c.* 1927, Frank Cresci (left), Esther Cresci, and Sal Cresci sit for a timeless photograph. The family rose to prominence in fishing, boatbuilding, and retail. (Courtesy of the Cresci family.)

Giuseppe and Rosa Cicalo are seen here at their El Cajon ranch around 1948. Upon retirement, they relocated to this rural area in an effort to recapture their Italian agricultural roots. They grew olive trees and canned the fruits of their labor, as their ancestors had done in Italy. (Courtesy of the Cicalo family.)

In a typical neighborhood shot in 1945, Balistreri family members are featured. From left to right are Tilly, Girolamo, Rosalia, and Filippo. (Courtesy of Pete Balestrieri.)

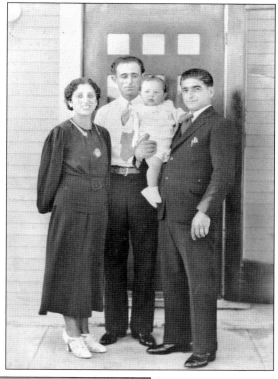

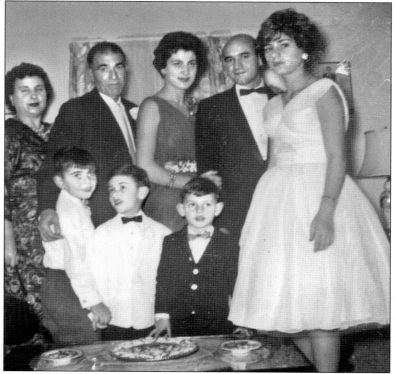

Members of the Balistreri family were new arrivals to the Italian colony from Aspra, Sicily, c. 1960. They moved into the Italian neighborhood and labored in nearby retail merchant facilities, such as the Macaroni Company and De Falco's grocery store. (Courtesy of the Cesarini family.)

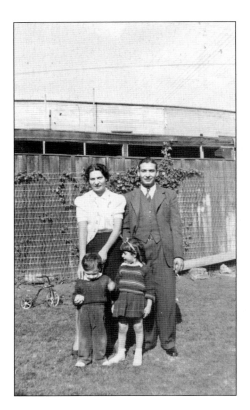

Ida and Frank Gibaldi stand with their children around 1940 in the backyard of their home. Frank was the owner of Roma Bakery on India Street. (Courtesy of the Motisi family.)

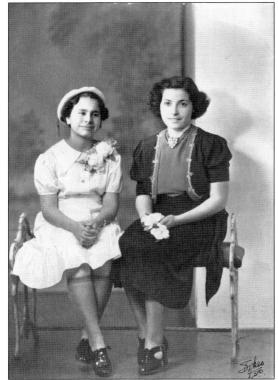

Catherine Cicalo (right) poses for a formal picture with a close family friend c. 1935. Just as with familial ties, friendships were also an important aspect of life in the neighborhood. (Courtesy of the Cicalo family.)

In 1936, the Collini and Marline families enjoy time together at the Marline home. The Marline garden was full of fig and loquat trees and had an abundance of morning glory and honeysuckle vines. Although this image was taken during the Depression, the Marline home typified the self-sufficiency of Italian homes with a vegetable garden. (Courtesy of Fran Marline Stephenson.)

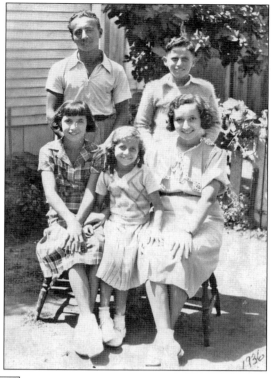

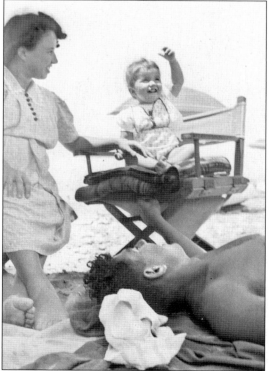

Adel Weber plays with her daughter Beverly while her brother Tod looks on in Ocean Beach in 1943. Families would often bring myriad amenities with them on their beach sojourns; frequently, in addition to blankets and chairs, the family toted a hot meal. (Courtesy of Adel Weber.)

Federico and Amelia Marline entertain their friend (right) in 1938 along the water's edge in Mission Beach. While many outings to the beach were often well orchestrated, spontaneous visits such as this one were also quite common. (Courtesy of Fran Marline Stephenson.)

The Zolezzi and DeLuca families gather in 1944 at Brant Street in part of the current Banker's Hill neighborhood. (Courtesy of the Cresci family.)

Pete Balestrieri (standing left), Joe Brunetto, and boys Filippo Puleo (seated left) and Rosario Puleo enjoy a photo opportunity in the neighborhood in 1950. (Courtesy of Pete Balestrieri.)

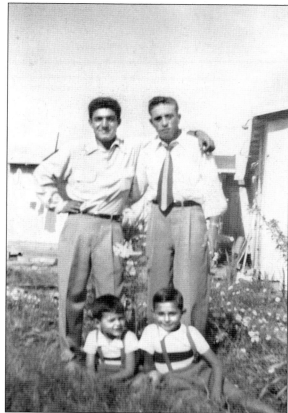

In 1940, the Ghio family ventured to Pine Valley, which offered a more diverse locale than what the community members were accustomed to in coastal outings. (Courtesy of Adel Weber.)

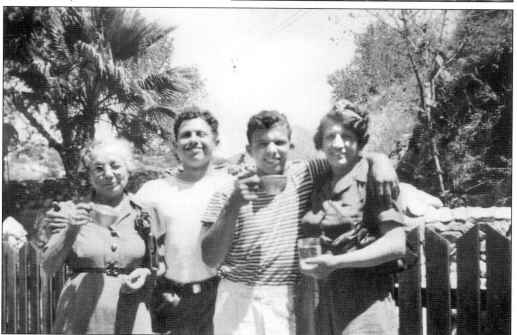

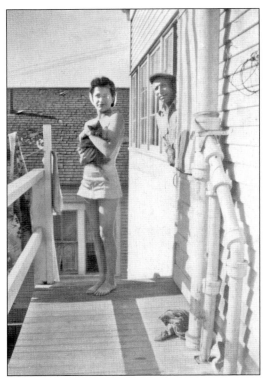

Toodles Marline holds the family cat on the back porch of the Marline home on India Street, while her father sneaks a glimpse. (Courtesy of Fran Marline Stephenson.)

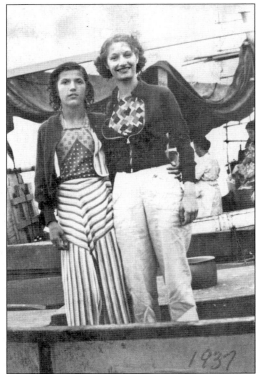

Fran Marline (left) is pictured with a close friend on their way to enjoy Coronado Island aboard the *Victoria*, a family fishing boat, in 1937. (Courtesy of Fran Marline Stephenson.)

Seen here in 1938, Joe and Fran Marline are at the home of their friend Tom Balestrieri (right) on Kettner Boulevard and Date Street. (Courtesy of Fran Marline Stephenson.)

Catherine Ghio (second from right on the sofa), pictured around 1950, is beaming while surrounded by her grandchildren in the family living room in their Union Street home. Seated on her right is her mother. The photograph depicts three generations of Italians in San Diego. (Courtesy of Adel Weber.)

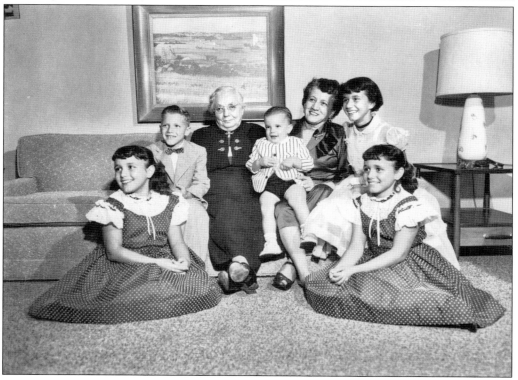

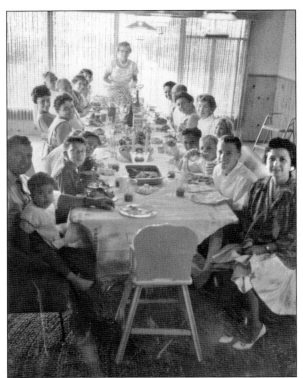

The Ghio home on Union Street always held an abundance of people and food during the holiday, as this c. 1960 image shows. (Courtesy of Adel Weber.)

The Ghio family would also venture outdoors for special events, such as this birthday party for one of the kids at Balboa Park around 1940. (Courtesy of Adel Weber.)

Four

SEA CHANGE
THE FISHING INDUSTRY

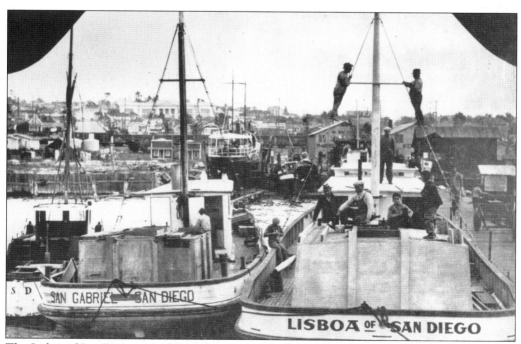

The *Lisboa of San Diego* was a fishing boat owned by Michael Balestrieri, who is seen working at the top of the mast on the left. To the left of the *Lisboa* is another fishing boat, the *San Gabriel*. Taken in 1925, the photograph looks toward the Italian colony, with Washington School in the background behind the *San Gabriel*. (Courtesy of Josephine "Jody" Balestrieri.)

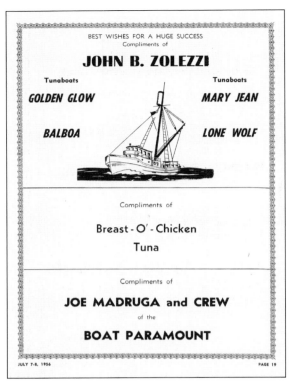

These two endorsements, which originally appeared in the program for the Italian Fair of 1956, clearly emphasize the role of the fishing industry in the Italian colony. Note the specific mention of Italian fishing families and their family boats. (Courtesy of Our Lady of the Rosary Parish.)

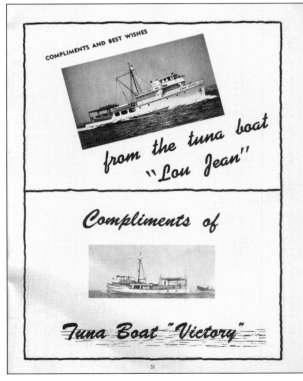

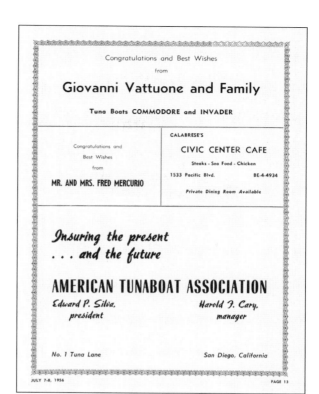

These endorsements are from the program for the Italian Fair of 1956. Such prominent fishing organizations as the American Tunaboat Association and Van Camp Sea Food Company are recognized in their support for the parish. (Courtesy of Our Lady of the Rosary Parish.)

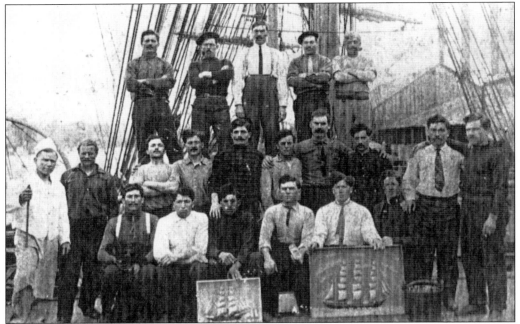

This early photograph, taken in 1917, is of the *Star of Holland* and its crew. The ship was built in 1860 and was used primarily for fishing salmon in Alaska. The *Star of Holland* is the sister ship to the *Star of India*, which remains in the San Diego harbor today. (Courtesy of Fran Marline Stephenson.)

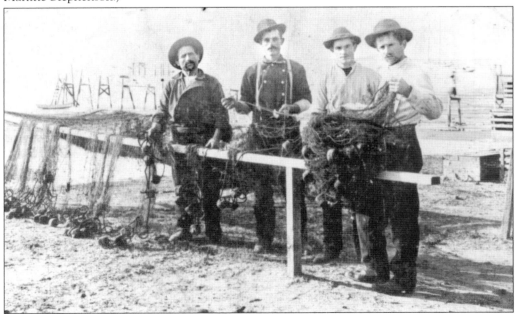

The crew of the *Star of Holland*—from left to right, Angelo Carneglia, Augustino Zolezzi, Berlin Zolezzi, and Angelo Zolezzi—mends nets ashore in Alaska in 1917. The fishing expeditions to Alaska would endure for four to six weeks; this particular expedition was with the Alaska Packer's Association. (Courtesy of the Maritime Museum of San Diego.)

In this early fishing photograph, taken around 1917 aboard the *Star of Holland* in Alaska, an Italian fisherman known by the crew simply as "Santa Claus" pauses for a brief puff of his pipe. (Courtesy of the Maritime Museum of San Diego.)

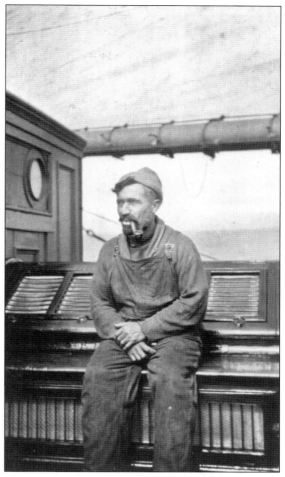

Retired California state senator (1869–1876) and California governor (1880–1883) George Clement Perkins (left) is seen aboard the *Star of Holland* with an unidentified Italian fisherman in 1917. Clement served as chairman for the congressional committee on fisheries in two separate congressional districts of California. Although retired, Perkins continued to take a special interest in California's maritime trade and the fishing industry in San Diego specifically. (Courtesy of the Maritime Museum of San Diego.)

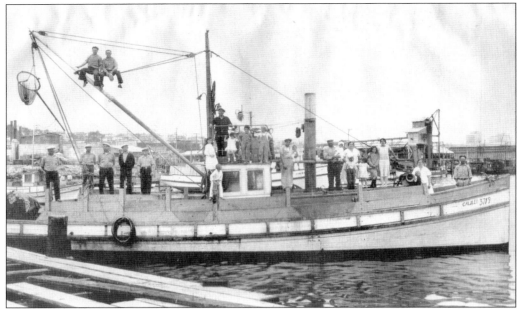

The *Galileo* was among the most recognized fishing boats in both San Diego and San Francisco harbors. It was built and owned by Gaetano "Tom" Cresci, who immigrated to California from Porticello, Sicily, in 1911. Upon arriving in America, Cresci went directly into the fishing industry, first in the San Francisco Bay and then in the San Diego Bay, where he fished for his entire life, until 1971. This photograph of the *Galileo* was taken in 1931. (Courtesy of Tom Cresci.)

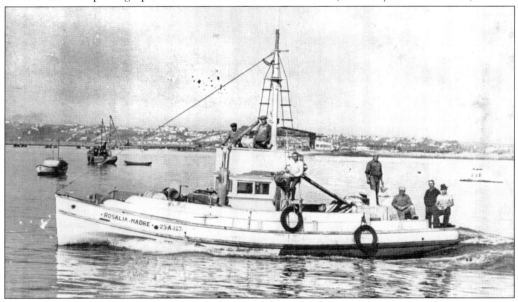

The *Rosalia Madre* was the sister boat to the *Giuseppe Madre*, both of which were well recognized in the San Diego Bay for tuna fishing. This image, taken from the harbor in the mid-1920s, captures the crew heading out for a day of tuna fishing. As was the case with the majority of Italian tuna clippers, the launch of the *Rosalia Madre* was celebrated with a ceremony on her first trip into the San Diego Bay. (Courtesy of the Waterfront Bar.)

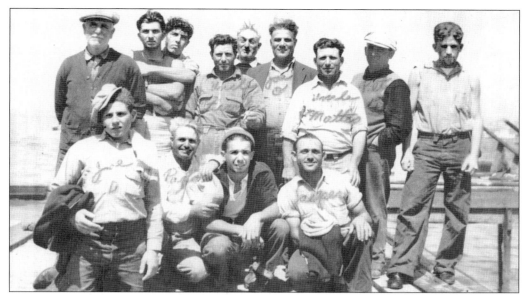

Italian fishermen on deck of an unidentified tuna boat c. 1935 clearly show the camaraderie that existed among the crew members. Note the generational differences among the men. When one's grandfather or father fished for tuna, it was typical for the succeeding generation to do the same. Not until World War II did the fishing industry give way to alternative employment opportunities for young Italian Americans, beginning with service in the armed forces. (Courtesy of the Waterfront Bar.)

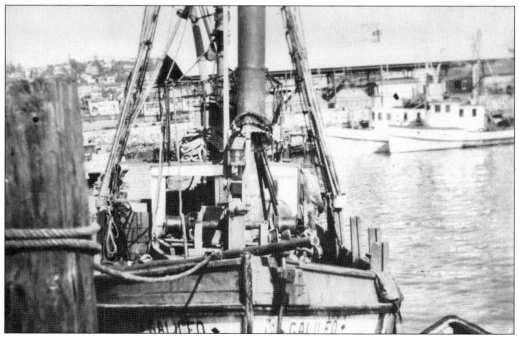

The tuna clipper *Galileo* sits anchored in the San Diego harbor, resting after a successful fishing expedition. Once the fish were unloaded from the boats, the crew spent days cleaning and preparing for the next expedition. (Courtesy of the Waterfront Bar.)

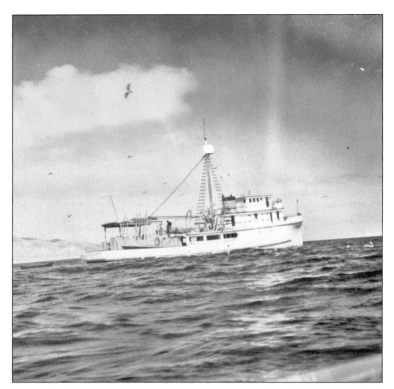

The *St. George*, built and owned by Michael Balestrieri, sails out to fish in San Diego Bay in 1940. Balestrieri was born in Porticello, Sicily, and immigrated to California in 1897. He came to San Diego via San Francisco. As was surprisingly common among many immigrants traveling to the West of the United States, the Balestrieri family did not enter the country through Ellis Island, but instead took the long route south, around Cape Horn in South America. (Courtesy of Josephine "Jody" Balestrieri.)

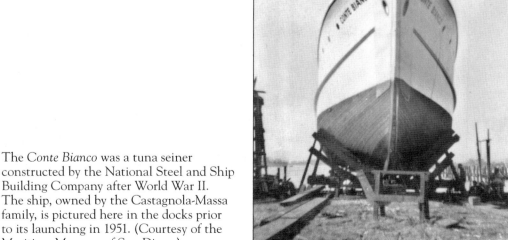

The *Conte Bianco* was a tuna seiner constructed by the National Steel and Ship Building Company after World War II. The ship, owned by the Castagnola-Massa family, is pictured here in the docks prior to its launching in 1951. (Courtesy of the Maritime Museum of San Diego.)

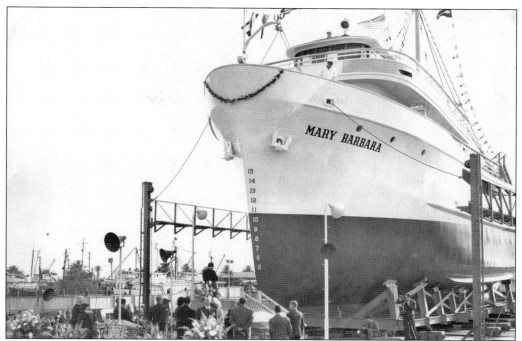

Also built by the National Steel and Ship Building Company, the *Mary Barbara* was among the first steel tuna clippers to be built in San Diego after World War II. It was massive in size; it spanned 106 feet in length, was 24 feet wide, and carried 160 tons. (Courtesy of the Waterfront Bar.)

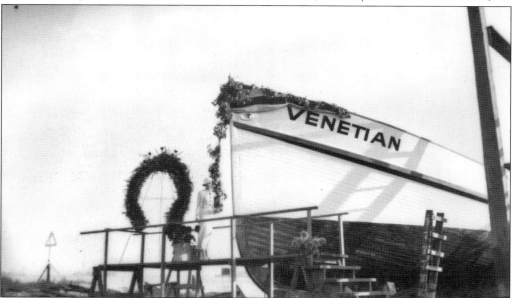

Preparations are made to launch the *Venetian c. 1947*. The tuna clipper was most active in the 1950s, primarily fishing sardines and tuna in Baja California. Although not as sophisticated or as large as the steel ships that would be built after the war, the *Venetian* earned a reputation among the Italian fishermen for sturdy service in stormy waters. (Courtesy of the Maritime Museum of San Diego.)

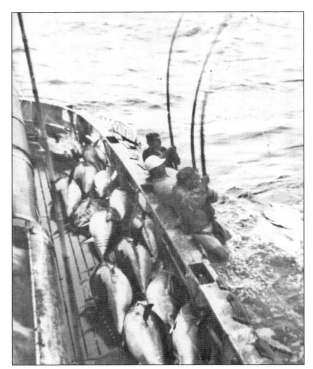

The crew aboard the *St. George* in 1950 practices the traditional skill of "pole fishing" for tuna. Pole fishing entailed fishing with a 10-foot-long bamboo pole, a 4-foot leader, and live bait. It took tremendous strength and skill to pull the large tuna up and over the fishermen's backs to the holding tanks along the length of the boat. Pole fishing was eventually given up in favor of purse seiner fishing, which involved the use of wide nets to gather the tuna. (Courtesy of Josephine "Jody" Balestrieri.)

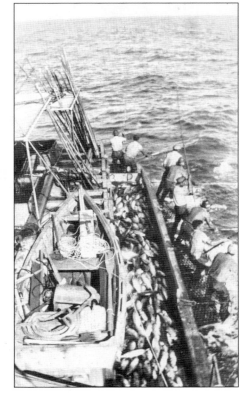

"Chumming"—tossing live bait to attract the tuna—and pole fishing are seen here in practice on the *City of San Francisco* in 1941. The average tuna weighed between 30 and 50 pounds, but it was not unheard of to catch a tuna weighing more than 100 pounds. The job required tremendous strength to pull the tuna up and over the side of the boat. (Courtesy of the Cresci family.)

Amelia Marline mends fishing nets, which were referred to as *lampara* or *paranzelle* by the Italians, in the backyard of the Carneglia home on Kettner Boulevard. Homes in the neighborhood with large, open yards were frequently used by the Italian fishing families to weave, stretch, dry, and mend the nets. When the men were out fishing, the women and children were often responsible for maintaining the nets. (Courtesy of Fran Marline Stephenson.)

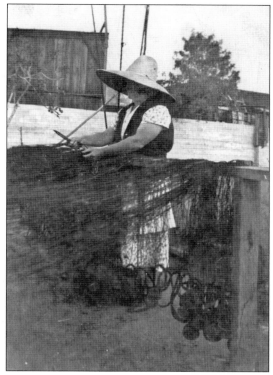

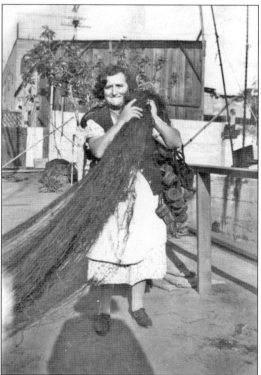

Amelia Marline carries the heavy *paranzelle* to the yard on Kettner Boulevard. The skill and expertise required to maintain the nets was apparent, and a number of community residents gained reputations as expert net makers. Salvatore "Sal" Cresci was one such fisherman. His expertise was so well recognized, in fact, that when the Sports Center opened at Balboa Park, Cresci was asked to weave nets for the volleyball courts. (Courtesy of Fran Marline Stephenson.)

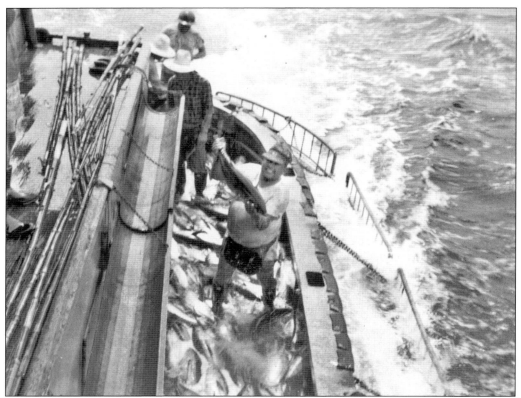

Although the tuna-fishing industry reached its peak in San Diego in the late 1920s, many families continued to fish well into the 1980s. (Courtesy of Pete Balestrieri.)

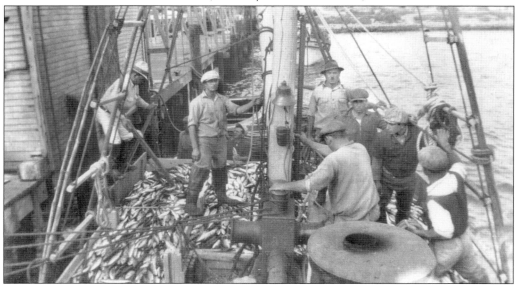

In this typical photograph of a fishing vessel, the fishermen prepare to carry their bounty back to the colony to be sold at the market or be taken directly to the canneries for processing. (Courtesy of Pete Balestrieri.)

All fishermen were required to carry a fishing license, especially when fishing in foreign waters. This permit, belonging to Tony Giacalone and dating from 1969, grants Giacalone fishing rights in Baja, California. The permit is typical of the documents that were required to be carried by the fishermen. (Courtesy of the Maritime Museum of San Diego.)

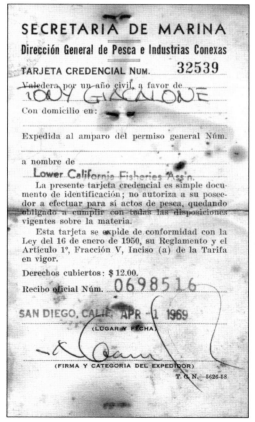

SECRETARIA DE MARINA

Dirección General de Pesca e Industrias Conexas

TARJETA CREDENCIAL NUM. 32539

Valedera por un año civil, a favor de

TONY GIACALONE

Con domicilio en:

Expedida al amparo del permiso general Núm.

a nombre de

Lower California Fisheries Ass'n.

La presente tarjeta credencial es simple documento de identificación; no autoriza a su poseedor a efectuar para sí actos de pesca, quedando obligado a cumplir con todas las disposiciones vigentes sobre la materia.

Esta tarjeta se expide de conformidad con la Ley del 16 de enero de 1950, su Reglamento y el Artículo 1º, Fracción V, Inciso (a) de la Tarifa en vigor.

Derechos cubiertos: $ 12.00.

Recibo oficial Núm. 0698516

SAN DIEGO, CALIF. APR -1 1969

(LUGAR Y FECHA)

(FIRMA Y CATEGORIA DEL EXPEDIDOR)

T. & N. 5626-58

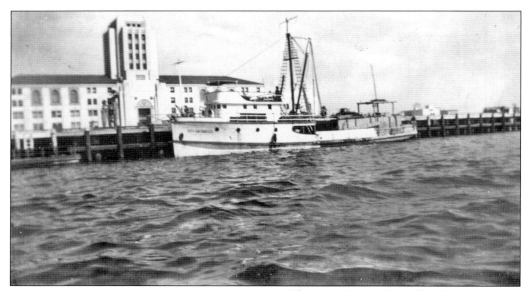

The tuna clipper *City of San Francisco*, built by Gaetano Cresci, sits in the San Francisco harbor around 1932. In the background is the San Francisco Civic Center. Cresci's boat was anchored in San Francisco for six months of the year and would return to San Diego for the remaining months. Although this tuna boat obviously bears the name of its original port city, Cresci would name successive fishing boats after every one of his children. (Courtesy of the Cresci family.)

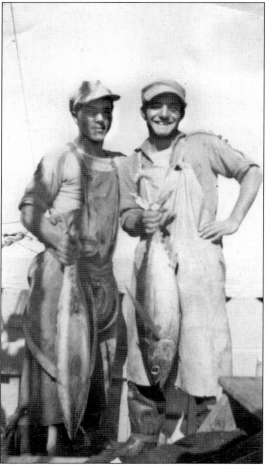

Pete Balestrieri (right) and his fishing buddy Eddie Pecoraro show off their catch of albacore. (Courtesy of Pete Balestrieri.)

Types of cold storage and storage capacity for the fish on the tuna clippers distinguished one boat from the other. During the war, because all tuna clippers possessed some type of refrigeration, they were most often taken by the U.S. government as yacht patrols. The "Yippies," as the wartime boats were called, were capable of transporting meat and other perishable goods. (Courtesy of the Waterfront Bar.)

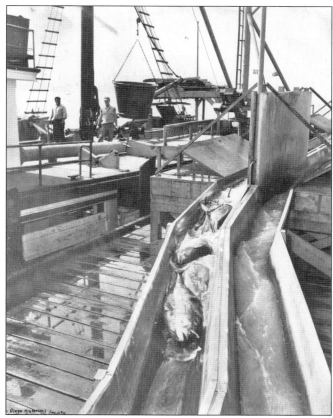

In this 1920s image, the launch of *La Querida* is celebrated by the press and local San Diegans. *La Querida* was the prized possession of Ulysses S. Grant IV, grandson of famed Civil War general Ulysses S. Grant. Grant IV lived in San Diego. Because of his fame and reputation in the city, a large crowd gathered at the harbor to witness the event. (Courtesy of the Waterfront Bar.)

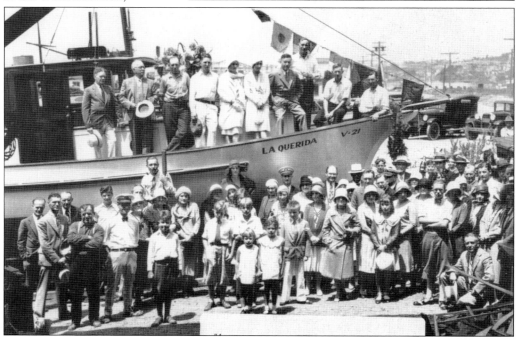

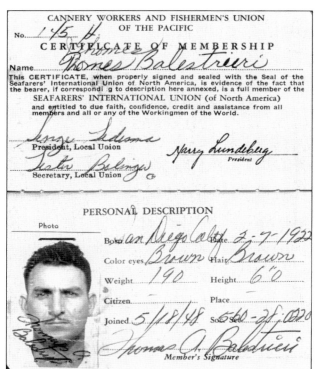

Many Italian immigrants living in the colony chose to enter into employment in the canneries rather than to fish. This document, dating from 1948, represents the significance of unionized labor in both the fishing and canning industries. The majority of fishermen belonged to the American Fishermen's Tuna Boat Association, whereas Thomas Balestrieri belonged to the Cannery Workers and Fishermen's Union of the Pacific. (Courtesy of Josephine "Jody" Balestrieri.)

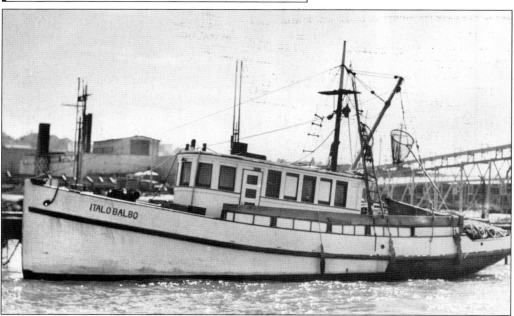

The tuna clipper *Italo Balbo* bears the name of famed Italian aviator Italo Balbo (1896–1940), who visited San Diego in 1928 and was greeted with a massive public reception. The cultural heritage of the Italian experience was kept alive not merely through the Italian methods of fishing that were brought to San Diego's Italian colony, but also through the choice of names borne by the tuna boats themselves. (Courtesy of the Waterfront Bar.)

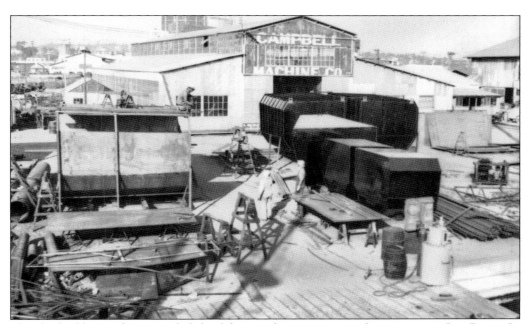

The shipbuilding industry rivaled the fishing industry in terms of its success in San Diego. In 1951, there were six major shipyards in San Diego. The Campbell Machine Company, established by Dave and George Campbell, was among the largest and most successful. (Courtesy of the Maritime Museum of San Diego.)

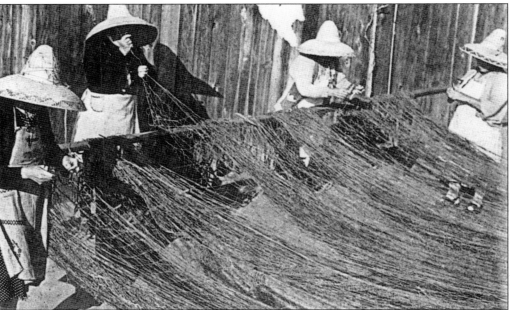

Everyone in a fishing family participated in some way to support the family income. Women and children, for example, often worked at home to untangle hooks from the halibut baskets or to prepare the smaller nets for the next day's sardine catch. In this image, taken in 1938, four women gather in a neighbor's backyard to stretch, dry, and mend the large purse seiner nets for tuna. (Courtesy of Fran Marline Stephenson.)

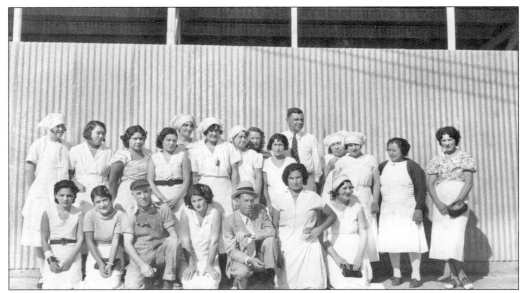

Workers pause for a break in the sunshine at Sun Harbor Cannery. In addition to fishing and shipbuilding, the fish-packing industry and canneries offered yet another source of employment for Italian immigrant families in San Diego. Italian men and women were joined by other immigrant workers, including Mexican and Japanese employees, in the factories. (Courtesy of the Cicalo family.)

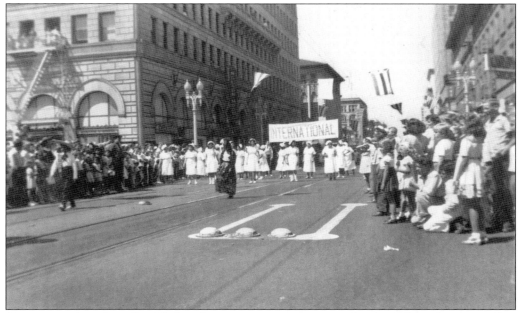

Cannery workers from Sun Harbor Cannery participate in a workers' parade in downtown San Diego around 1930. As was the case with other sectors of the fishing industry, cannery workers were unionized in the United Fish Canneries Workers Union. (Courtesy of the Cicalo family.)

Rosa Cicalo stands out among the many Italian women and men who worked the long, hard hours on the cannery factory floors. Cicalo was recognized for her longtime service to Sun Harbor Cannery upon her retirement. Sardine canneries were the first fish-canning facilities in San Diego; tuna canning followed shortly thereafter. (Courtesy of the Cicalo family.)

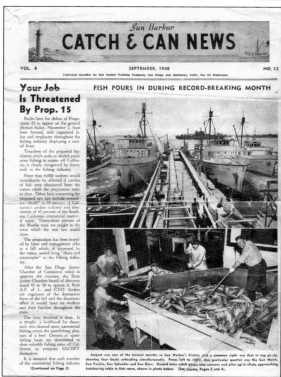

This monthly newsletter, quaintly titled *Catch and Can News*, was issued by Sun Harbor Cannery and was typical of the canneries' efforts to maintain positive employee relations. (Courtesy of the Cicalo family.)

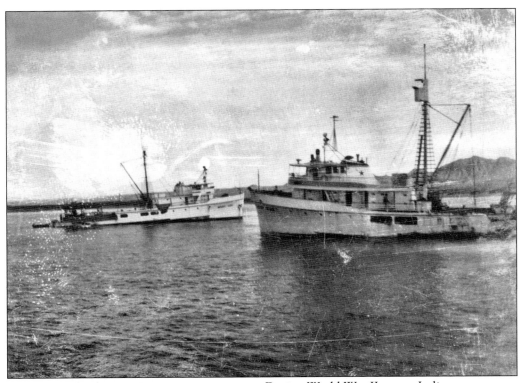

During World War II, many Italian tuna clippers were taken by the U.S. Navy. The *St. George* is pictured on the right in 1950, after being returned from the government after the war. The U.S. government had used the boat as a supply ship in the Phillipines. Unfortunately, in 1954, the *St. George* sank on return from a fishing expedition to San Pedro. (Courtesy of Josephine "Jody" Balestrieri.)

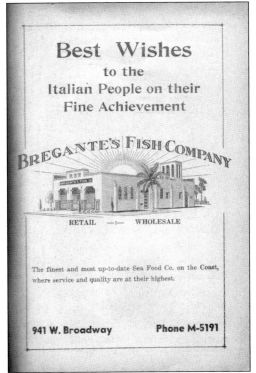
Tuna fishing, shipbuilding, and canneries were thriving industries in San Diego. Bregante's Fish Company joined the fray when it opened its doors as a retail section of a wholesale fish market along the harbor in 1916. (Courtesy of Our Lady of the Rosary Parish.)

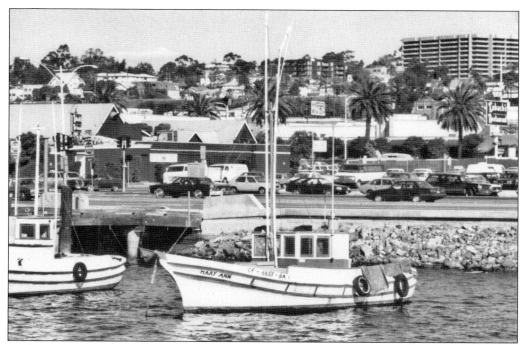

In this early-1970s image, two small tuna boats, the *Diana* and the *Mary Ann*, float along the harbor. The boats, now refurbished, continue to attract onlookers walking along the waterfront in front of the Maritime Museum. (Courtesy of the Maritime Museum of San Diego.)

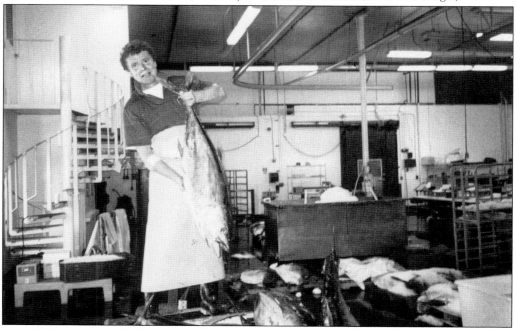

Frank D'Amato in this 2002 image holds up a tuna at Ghio Seafood Commissary, where he served as the foreman for nearly 30 years. D'Amato is an immigrant from Porticello, Sicily. (Courtesy of the D'Amato family.)

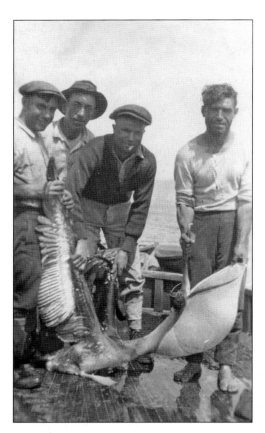

Ghio cousins and friends catch a pelican while fishing on the family boat. Both pelicans and seagulls were a nuisance to the fishermen because they would steal the catch. On this day in 1935, however, the fishermen fared better. (Courtesy of Adel Weber.)

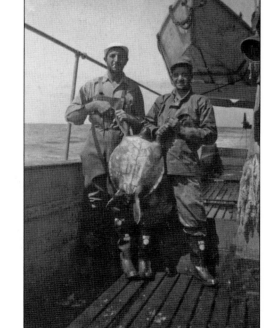

This is a fishing scene aboard the *Catherine*, the vessel built and owned by Sal Cresci (right). Cresci and his mate also managed to catch a turtle on their excursion. (Courtesy of Salvatore Cresci.)

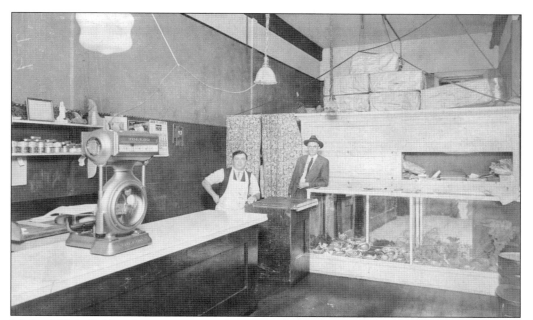

Michael Ghio (left) and a cousin are ready to serve fish at the Sunset Sea Food Company around 1925. The Ghio fish retail business would thrive initially, according to the family, from the cleverly devised display cases that were used to show off the fresh fish. In addition, the Italian-inspired fish sauces set out along the service counter were without rival. (Courtesy of Anthony Ghio.)

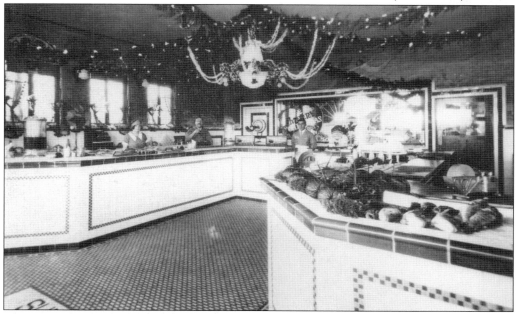

The original oyster bar and open fish counter is the focus of this photograph, taken at Sunset Sea Food Company at Christmas 1930. Inspired by the success of her father's retail fish business, Catherine "Mama" Ghio had a vision for her family's future in yet another kind of retail seafood industry—the restaurant business. In 1946, Mama Ghio would establish Anthony's Fish Grotto, which remains one of San Diego's most successful restaurants today. (Courtesy of Anthony Ghio.)

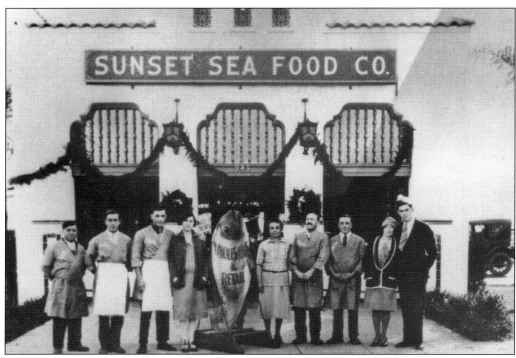

Bregante's Fish Company grew to become the Sunset Sea Food Company. This image of workers outside the company dates from the 1930s. (Courtesy of Anthony Ghio.)

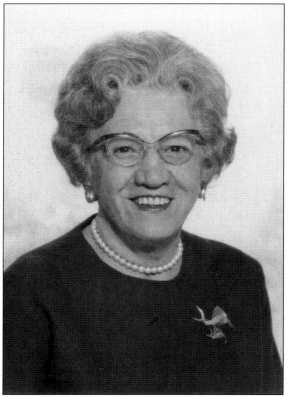

Mama Ghio, founder of Anthony's Fish Grotto, is pictured here in 1960 on the occasion of her being honored by the Italian government for her contribution to San Diego. She also received an honorary medal for her life's work. (Courtesy of Anthony Ghio.)

Five

SLICE OF LIFE
PASTIMES AND SOCIAL STRUCTURES

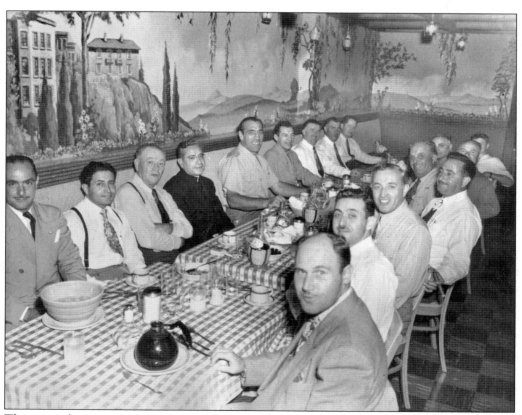

This scene depicts a typical gathering of Italian friends at a local Italian restaurant c. 1942. Fifth from the left is Primo Carnera, the Italian heavyweight boxing champion of 1933. (Courtesy of Anthony Ghio.)

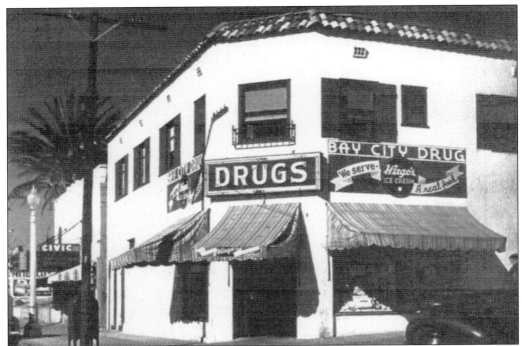

The Bay City Drug Store, built in 1931, was owned by Emilio and Giulia Giolzetti. In addition to providing general goods, the drugstore boasted a very popular soda fountain that proved to be a destination for young residents of Little Italy. (Courtesy of the Cresci family.)

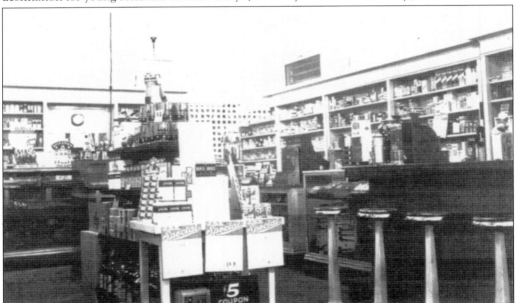

The interior of the Bay City Drug Store reveals its full shelves and soda stand. This type of establishment offered much more than mere consumer goods during the Depression and war era. It also captured the social pulse of the community by providing an outlet for social interaction. (Courtesy of the Cresci family.)

This 1950s advertisement for Dryer's Standard Furniture Company represents one of many retail merchants providing goods to the community residents. Other successful merchants in the neighborhood included grocery stores, shoe-repair stores, and barbershops, all of which provided essential services to residents. (Courtesy of Our Lady of the Rosary Parish.)

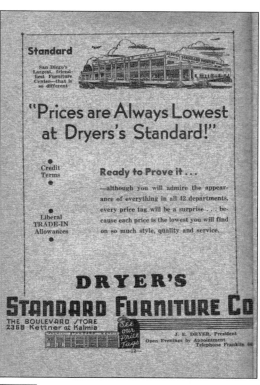

This insert from the program for the 1956 Italian Fair hosted by Our Lady of the Rosary Parish more than suggests the influence of the church in and around the community. Danny Thomas served as honorary host for the fair, held at San Diego's famed El Cortez Hotel, and the guest list included many other luminaries. (Courtesy of Our Lady of the Rosary Parish.)

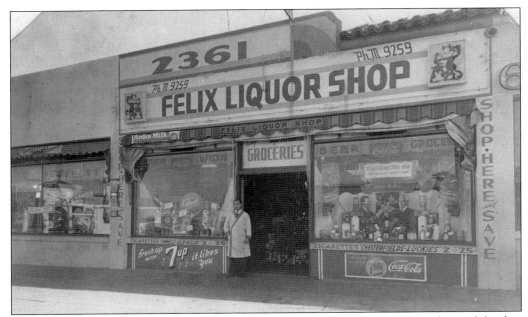

The Felix Liquor Shop, here portrayed in the mid-1930s, was located on the main thoroughfare but just outside of the heart of the neighborhood on India Street. It was owned by the Motisi family. As the image depicts, although the shop offered beer, wine, and other liquor, it also provided groceries and the ever-popular Coca-Cola and 7-Up soft drinks. (Courtesy of the Motisi family.)

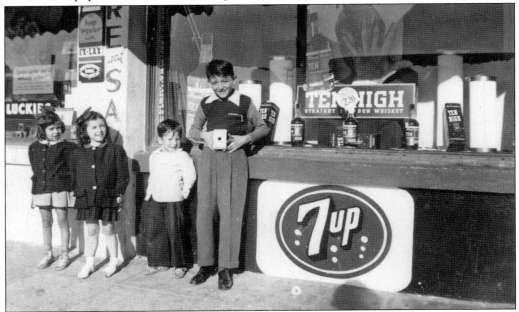

Children gather in front of Felix Liquor Shop. In contrast to today, children growing up in Little Italy often wandered the streets without their parents, often accompanied by older siblings. Because of the bonds and familiarity within the community itself, children were safe to visit Felix Liquor Shop, in this case because they would have known the shopkeepers and would have been looked after by neighbors, shop owners, and others. (Courtesy of the Motisi family.)

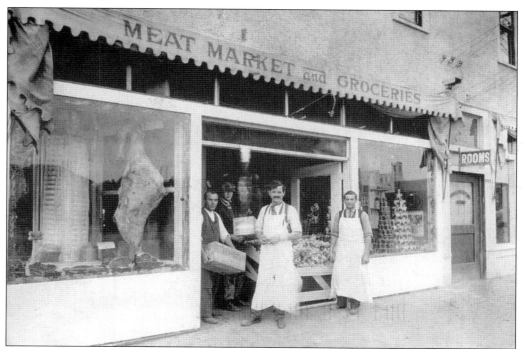

Tait's Meats was one of the earliest food retailers in the neighborhood. For those families who were not working in the fishing industry, the family grocery store provided secure employment in the neighborhood. (Courtesy of Fran Marline Stephenson.)

In addition to Felix Liquor Shop, pictured here, a handful of other groceries were established in the neighborhood—among them Italos, DeFalcos, and the very first grocery store in the neighborhood, the Bernardini grocery store, located where La Pensione Hotel now stands on India Street. (Courtesy of the Motisi family.)

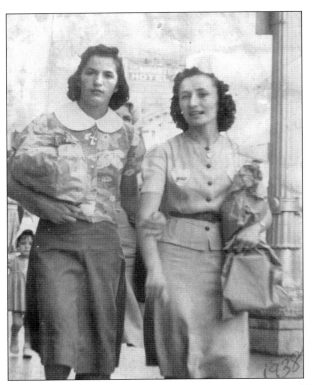

Fran Marline (left) and Francis Collini are pictured here on a shopping spree downtown on Broadway. Although the Depression endured, the Italian neighborhood persevered, and community members even found opportunities to spend money, as this 1938 image depicts. (Courtesy of Fran Marline Stephenson.)

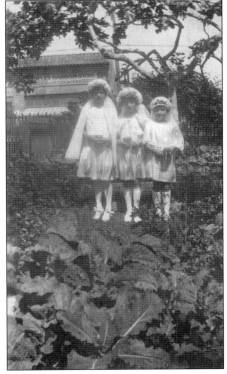

In 1929, Eleanor Zolezzi (left), Gertrude Zauri (center), and Fran Marline stand in the Marline garden, posing for a picture on the occasion of their First Holy Communion. (Courtesy of Fran Marline Stephenson.)

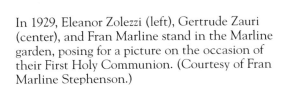

The Roman Holiday Ensemble, ubiquitous during the annual Little Italy Festa, marches through the streets with a significant following in celebration of the Italian national soccer team's 2006 World Cup victory. (Courtesy of Giovanna di Bona.)

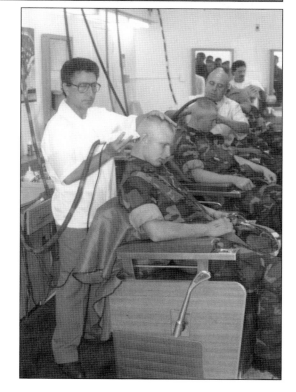

Andrea Cesarini is seen here at work in the Marine Corps Recruit Depot barbershop, where he has worked for more than 40 years. Cesarini came to San Diego from Aspra, Sicily. (Courtesy of the Cesarini family.)

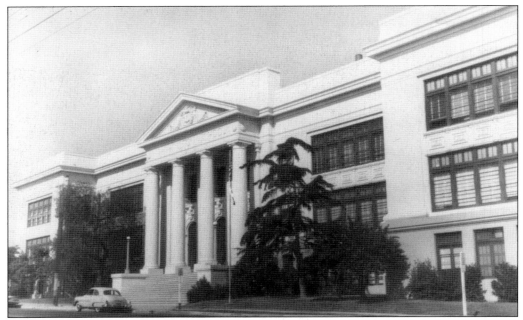

Washington School was architecturally modeled after the White House. When this photograph was taken in 1940, the interior was made predominantly of marble. Lion heads originally marked the front entrance but were later removed. The school served the entire Italian community. Sadly, the original building was torn down in 1980. The school, however, was rebuilt for another generation of young San Diegans. (Courtesy of Fran Marline Stephenson.)

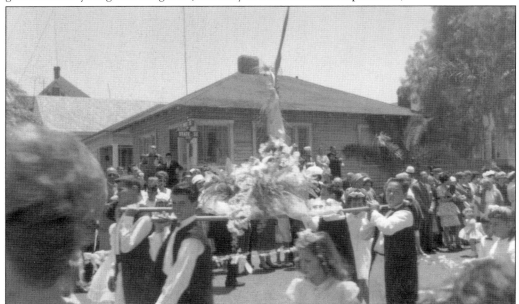

Across from Our Lady of the Rosary Parish, participants parade in a church procession. In the background is the Fry home, where Mrs. Fry often welcomed neighborhood children to join her after school for fun activities. Many Italians fondly recall spending afternoons at Mrs. Fry's home. (Courtesy of Fran Marline Stephenson.)

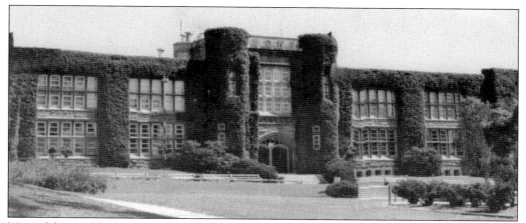

Most of the neighborhood youth attended San Diego High School, pictured here, after first going to Washington School and Roosevelt Junior High School. The three schools provided the foundation for the education of young Italians in the neighborhood. (Courtesy of the Cresci family.)

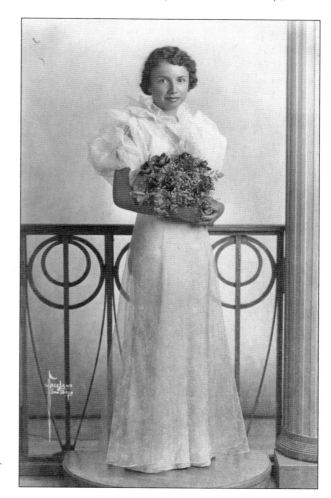

Adel Weber poses for a picture on the occasion of her graduation from San Diego High School in 1936. Such formal photographs were common upon graduation from high school and reflect the significance of having completed a high school education. (Courtesy of Adel Weber.)

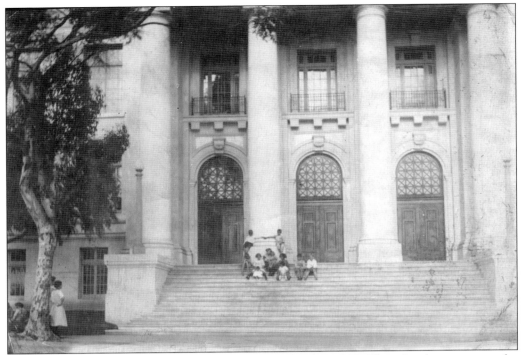

Children are seated on the steps of Washington School *c.* 1920. The school towers over the children, once again signifying its prominence in the community as the structure in which the children began their formal American education. (Courtesy of Fran Marline Stephenson.)

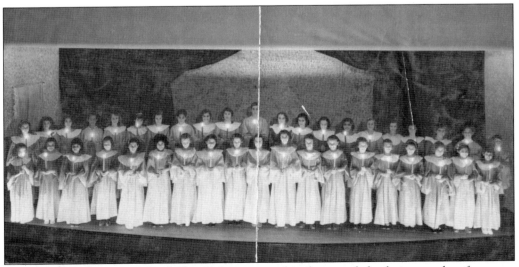

Members of Washington School Glee Club appear in this photograph for their annual performance in 1936. Both boys and girls were encouraged to participate in extracurricular activities, which helped to integrate young Italians into the American way of life. (Courtesy of Fran Marline Stephenson.)

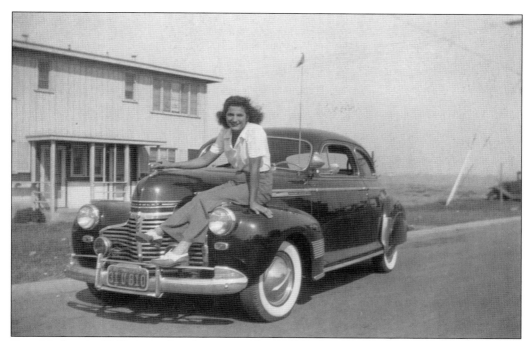

Fran Marline in 1942 sits on her first car, a Chevy Club Coupe, which she purchased with her brother. As young Italians became comfortable with their new American way of life, an important element of transition was gaining independence in adolescence by owning an automobile. (Courtesy of Fran Marline Stephenson.)

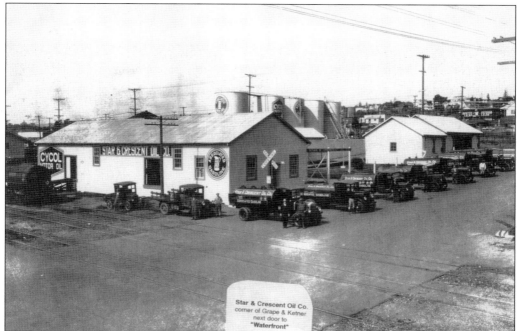

One of the first gas stations in the neighborhood was the Star and Crescent Oil Company, located on Kettner Boulevard and Grape Street, c. 1930. (Courtesy of the Waterfront Bar.)

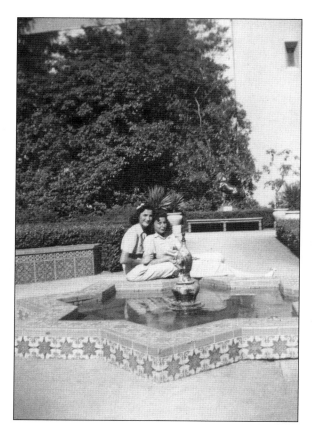

Fran Marline (left) and Sara Terramagra sit by a fountain in Balboa Park in 1940. The two young Italian women forged a friendship early on that has lasted for decades. Many early residents in the community, although now living in other parts of the city, have maintained their friendships and often meet to recount their childhood memories of the old neighborhood. (Courtesy of Fran Marline Stephenson.)

Children celebrate Tom Cresci's third birthday in 1947 at a party in Balboa Park. It was common to hold festivities for special occasions at Balboa Park, as there were no playing fields in or around the Italian colony. (Courtesy of Tom Cresci.)

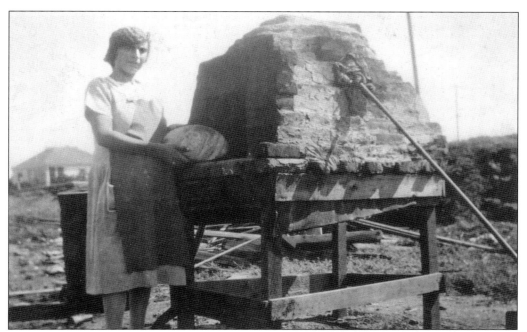

Rosa Cicalo in 1930 makes her own bread in an outdoor oven at her home in Barrio Logan. This practice was carried over from Italy, and many homes in the neighborhood boasted outdoor ovens. Such outdoor "kitchens" fostered a unique environment for spontaneous social gatherings. (Courtesy of the Cicalo family.)

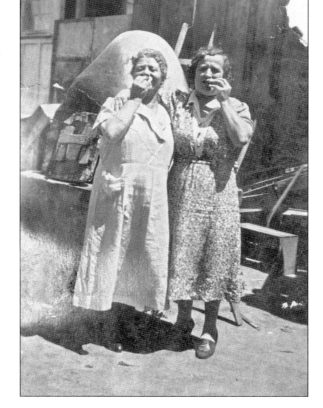

Two women pause to gleefully eat the fruits of their labor in 1939—freshly baked bread straight from the backyard oven. Even though the locals had a bakery to go to, there existed a sense of pride in baking one's own bread, especially during hard times. (Courtesy of Fran Marline Stephenson.)

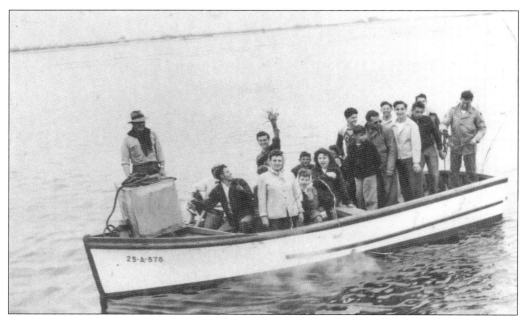

The Cresci family sets out in 1939 for Coronado Island to enjoy their regular picnic outing. Many families would travel to the bay side of Coronado in their tuna vessels—or in this case, in smaller skiffs—for short daily trips. (Courtesy of the Cresci family.)

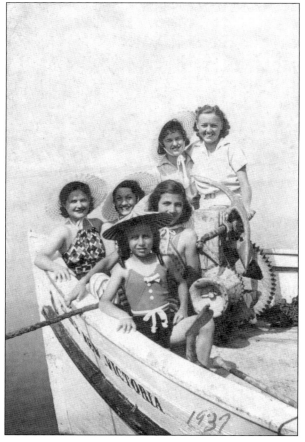

A group of cousins in 1937 eagerly anticipates a fun-filled Fourth of July celebration on Coronado Island. In this image, the *Victoria*, a tuna boat owned by Augusto Zolezzi, transports the girls across the bay. (Courtesy of Fran Marline Stephenson.)

If not spending time around the neighborhood, families like this one would pass an afternoon in creative feats, such as digging for clams in Coronado. In this *c.* 1926 image, Francis Cresci is kneeling holding the bucket. (Courtesy of the Cresci family.)

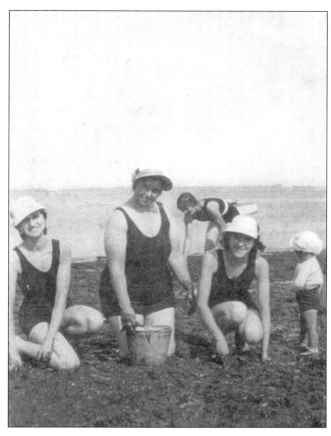

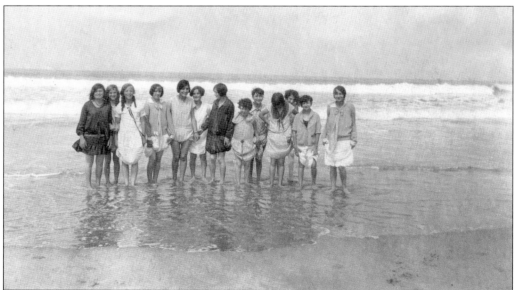

Young women on the beach celebrate a getaway from the hustle and bustle of the busy neighborhood streets. (Courtesy of Our Lady of the Rosary Parish.)

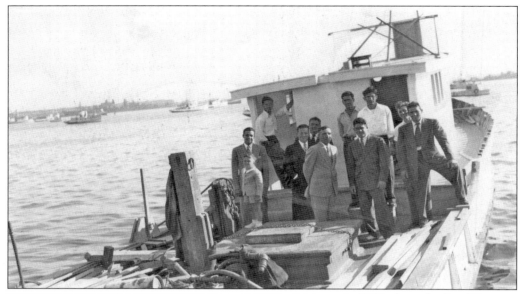

In 1949, along the San Diego embarcadero, the Cresci family celebrates the expansion of the fishing vessel *Galileo* from 45 feet to 60 feet. Pictured are three generations of Cresci family members. (Courtesy of the Cresci family.)

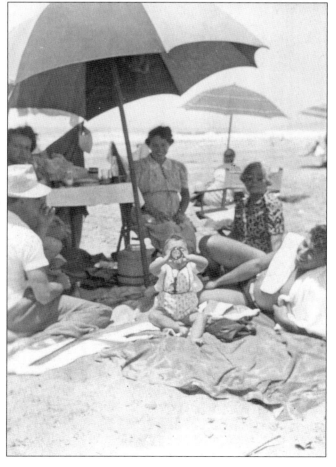

Excursions to the beach, such as the one pictured here around 1930, often entailed bringing along every amenity necessary to ensure all the comforts of home. Rather than sandwiches and other typical beach-picnic fare, pasta, steaks, and fish were the order of the day. (Courtesy of Adel Weber.)

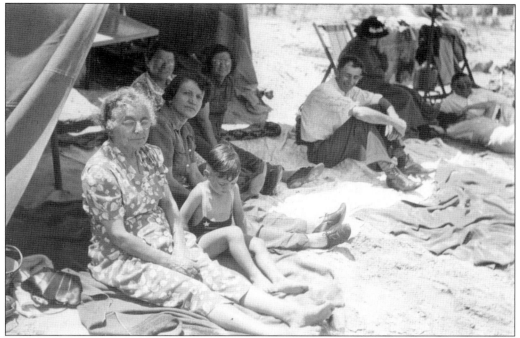

The Ghio family in 1940 relaxes in the shade of their tents in Mission Beach, a popular area for Sunday picnics. The beach provided an ideal venue of activities for several generations to enjoy. (Courtesy of Adel Weber.)

Pictured from left to right, Rose Cresci, Tom Cresci, and Giulia Zolezzi relax in the warmth of Warner Hot Springs, a favorite destination for Italian colony families, c. 1949. (Courtesy of Tom Cresci.)

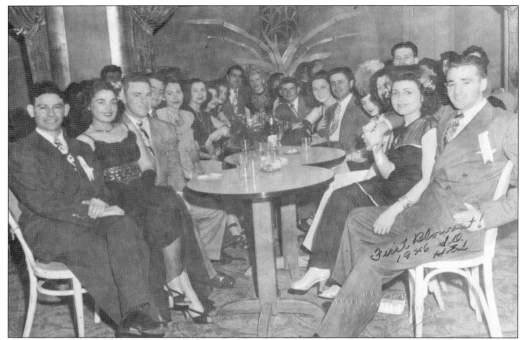

The first ITAMS (Italian American) Blowout party occurred in 1946 at the San Diego Hotel. The annual festivities were always celebrated between Christmas and the New Year because the fishing fleets were always home for the holidays. The Blowout is the longest continuing Italian-oriented social event in San Diego. (Courtesy of the Cresci family.)

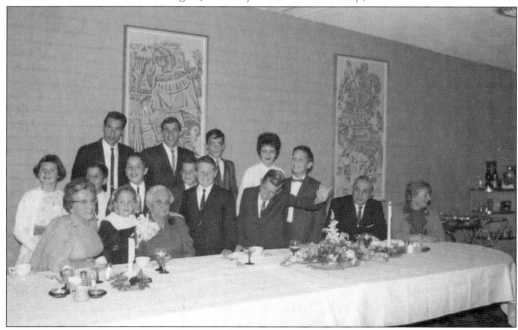

The Bregante, Ghio, and Weber families celebrate a reunion in 1963 at an Italian restaurant outside the heart of the neighborhood, on Fifth Avenue and Laurel Street. (Courtesy of Adel Weber.)

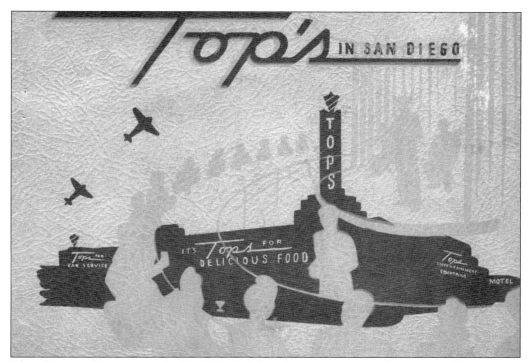

This photograph cover case for Top's Nightclub in San Diego was used to capture the evening's events. Top's was host to numerous wedding receptions, black-tie parties, and general evenings on the town after the war. (Courtesy of the Cresci family.)

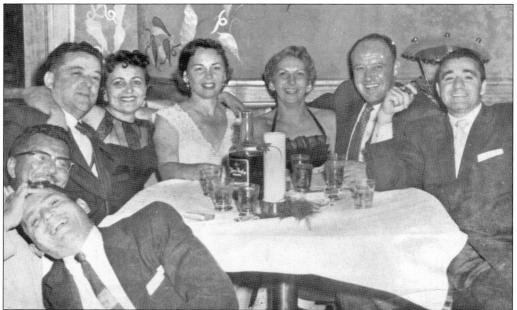

In 1954, the ITAMS Blowout was held at Top's Nightclub on Hawthorne Avenue and Pacific Highway, where Fat City is today. Top's was *the* nightclub of choice for the community. (Courtesy of the Cresci family.)

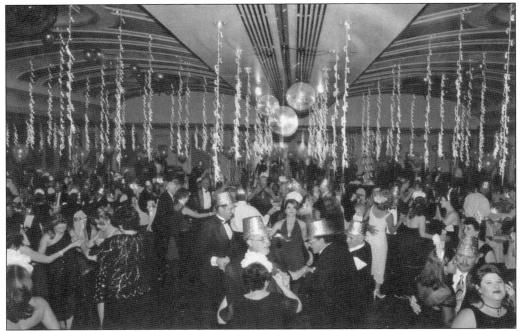

The ITAMS Blowout continues to be an annual celebration, as seen in this modern photograph. In the last several years, the Blowout has been held at the U.S. Grant Hotel in downtown San Diego. Elaborate decorations and glitter highlight the evening. (Courtesy of the Cresci family.)

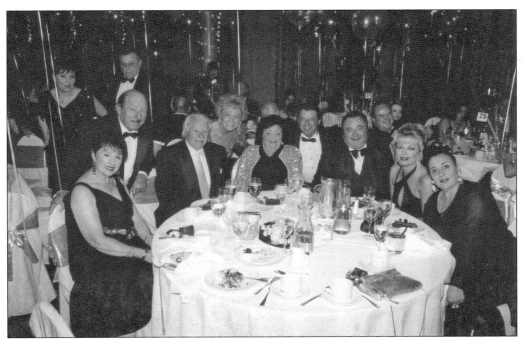

In this 2004 photograph, the contemporary Blowout committee enjoys the evening and discusses future events over dinner. (Courtesy of Tom Cresci.)

A group of friends gathers in 1942 at La Jolla Shores, another popular getaway destination for community residents. (Courtesy of Fran Marline Stephenson.)

In 1939, a trio of friends heads out for a day of fun and sun in Coronado Bay. (Courtesy of Fran Marline Stephenson.)

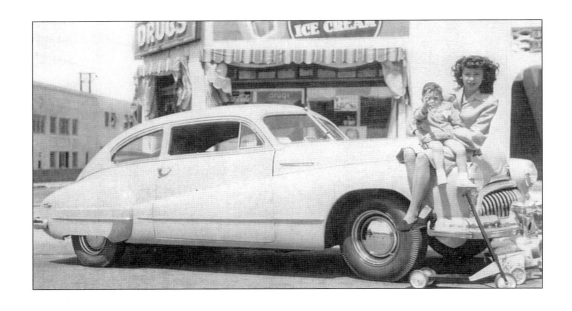

Cousins Tom Cresci and Florence DeLuca sit atop an automobile in 1947. In the background is Bay City Drug Store, established by Emilio and Giulia Giolzetti in 1931. The modern mural below portraying a series of Italian colony images included this photograph as its centerpiece. (Courtesy of the Cresci family.)

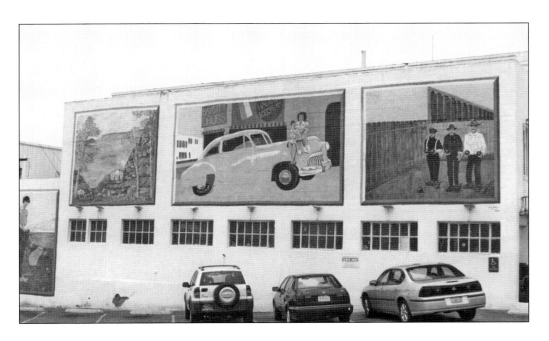

This personal letter of introduction in 1944 was written by Frank Deluca to his great-nephew Tom Cresci upon Tom's birth. Frank Deluca came to the Italian colony by way of Julian, California. After pursuing a career in acting and becoming the local butcher, he eventually retired as a successful real estate investor. (Courtesy of Tom Cresci.)

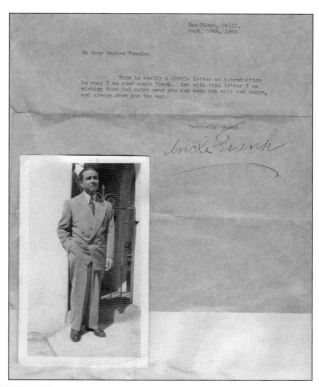

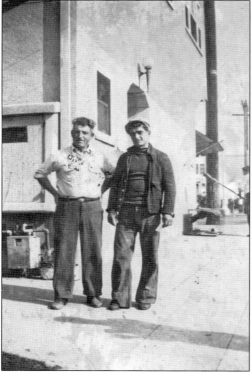

Two immigrant laborers pause on a street corner in the neighborhood after a full day's work c. 1942. (Courtesy of Pete Balestrieri.)

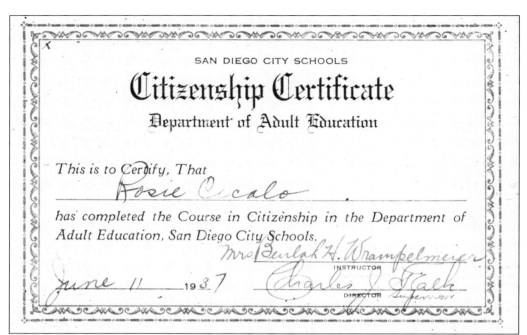

SAN DIEGO CITY SCHOOLS

Citizenship Certificate
Department of Adult Education

This is to *Certify, That*

Rosie Cicalo

has completed the Course in Citizenship in the Department of Adult Education, San Diego City Schools.

Mrs. Beulah H. Wrampelmeier
INSTRUCTOR

June 11 1937 *Charles J. Falk*
DIRECTOR *Supervisor*

Rosa Cicalo received this certificate citing her completion of a course in citizenship in 1937 from the San Diego City Schools. (Courtesy of the Cicalo family.)

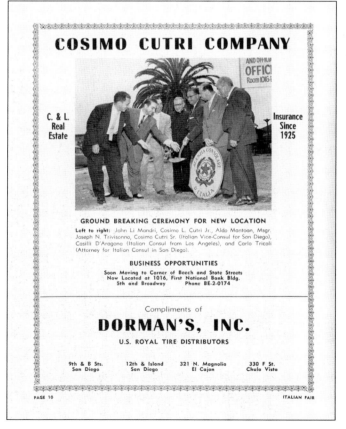

COSIMO CUTRI COMPANY

C. & L. Real Estate

Insurance Since 1925

OFFICE Room 1016

GROUND BREAKING CEREMONY FOR NEW LOCATION
Left to right: John Li Mandri, Cosimo L. Cutri Jr., Aldo Mantoan, Msgr. Joseph N. Trivisonno, Cosimo Cutri Sr. (Italian Vice-Consul for San Diego), Casilli D'Aragona (Italian Consul from Los Angeles), and Carlo Tricoli (Attorney for Italian Consul in San Diego).

BUSINESS OPPORTUNITIES
Soon Moving to Corner of Beech and State Streets
Now Located at 1016, First National Bank Bldg.
5th and Broadway Phone BE-2-0174

Compliments of

DORMAN'S, INC.

U.S. ROYAL TIRE DISTRIBUTORS

9th & B Sts. 12th & Island 321 N. Magnolia 330 F St.
San Diego San Diego El Cajon Chula Vista

PAGE 10 ITALIAN FAIR

An advertisement page in the program for the 1956 Italian Fair shows Cosimo Cutri, the Italian vice-consul of San Diego, standing third from right next to Msgr. Joseph Trevisonno. (Courtesy of Our Lady of the Rosary Parish.)

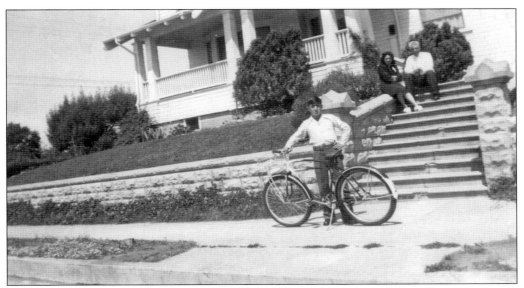

Pete Balestrieri stands next to his bicycle on Redwood Street in 1947. Although automobiles altered the way of life for many residents, others continued to rely on bicycles as an important mode of transportation. (Courtesy of Pete Balestrieri.)

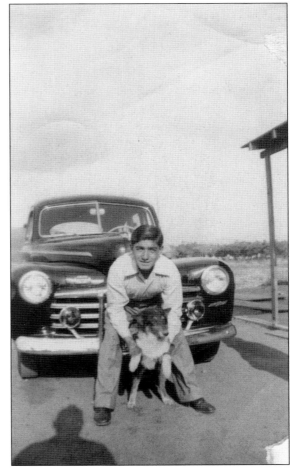

Pete Balestrieri in 1948 holds his dog in front of a 1946 Ford. This wartime-era photograph captures daily life in the Italian colony. (Courtesy of Pete Balestrieri.)

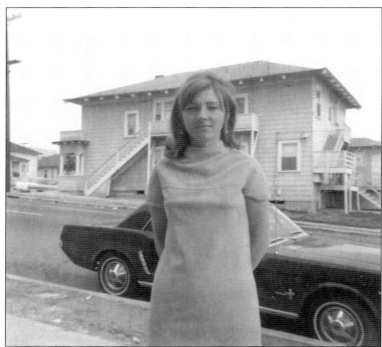

Margaret Cesarini stands in front of her new Ford Mustang on Kettner Boulevard in 1964. At 17, she came from Aspra, Sicily, with her family. Although young immigrants were encouraged to go immediately to work, she valued the importance of education. (Courtesy of the Cesarini family.)

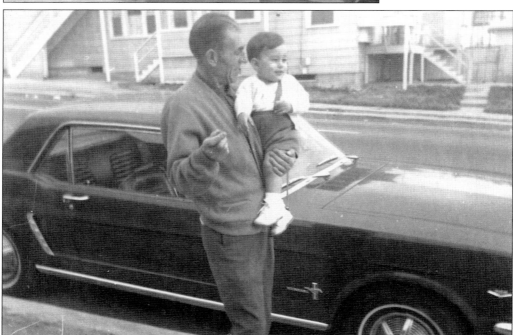

Pietro Balistreri holds his grandson Tommy Cesarini c. 1968 along Hawthorne Street near his home. His daughter's Ford Mustang is parked prominently on the street. Balistreri would later move his family to the suburbs. By this time, many families had already moved out of the neighborhood as a result of highway construction (Interstate 5) directly within the neighborhood, modernization thus displacing many residents. (Courtesy of the Cesarini family.)

Amelia Marline in 1938 mends the fishing nets at the Carneglia home. The San Diego Macaroni Company, located on Kettner Boulevard, appears in the background. The company employed a large number of community residents. (Courtesy of Fran Marline Stephenson.)

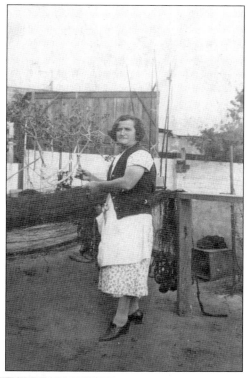

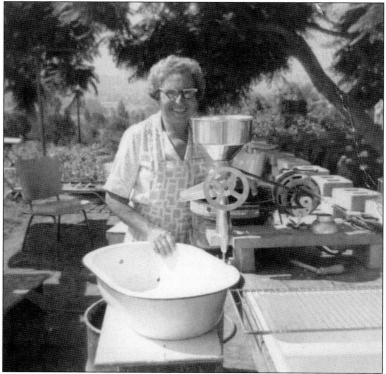

Even after leaving the neighborhood after the war, former residents continued to carry on Italian traditions in their respective new neighborhoods. In this image, taken around 1950, Rosa Cicalo makes sausage from a family recipe at her El Cajon ranch. (Courtesy of the Cicalo family.)

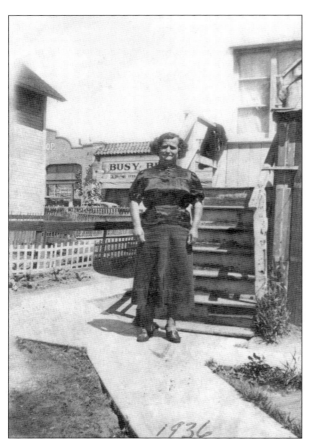

In 1936, the Busy Bee Grocery store served the community and was located where the modern Little Italy sign now towers over the revitalized neighborhood. (Courtesy of Fran Marline Stephenson.)

The Marline family members, pictured here around 1937, stand in front of their home on India Street. Their home was located adjacent to where La Pensione Hotel stands today. (Courtesy of Fran Marline Stephenson.)

In 1939, Father Pilolla achieved his dream of establishing a parish hall for the church youth. This program cover is for the parish hall inauguration event. Father Pilolla replaced the parish's founder, Father Rabagliati, in 1935 after Rabagliati returned to Italy because of failing health. (Courtesy of Our Lady of the Rosary Parish.)

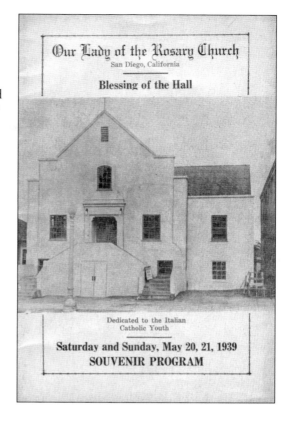

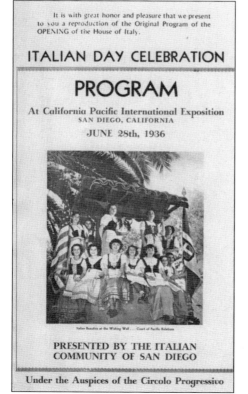

This program cover for the Italian Day Celebration in 1936 shows the importance and reach of the Italian colony outside the confines of India Street. The exposition was held in Balboa Park. (Courtesy of the Motisi family.)

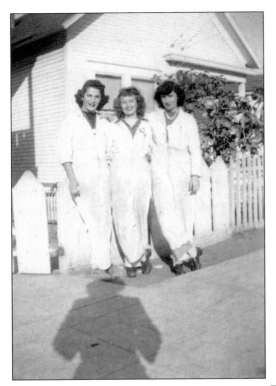

Three Convair factory workers in 1942 don the company uniform. The important role of women in the wartime effort is emphasized here, as women stepped out of their traditional familial roles at home to enter the workforce. (Courtesy of Fran Marline Stephenson.)

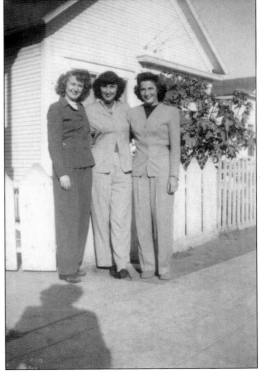

Fran Marline (in uniform on right) is joined by her comrades from the Convair plant. The women played an instrumental role in the wartime factories as electricians, working on the electrical units for the B-24 bombers. (Courtesy of Fran Marline Stephenson.)

During the war, the majority of the Italian colony's men served in the armed forces. San Diego was directly affected by the war, and as a consequence so, too, were the lives of local San Diegans. This image from 1944 captures a typical sight of a sailor in uniform on shore leave in San Diego. (Courtesy of Fran Marline Stephenson.)

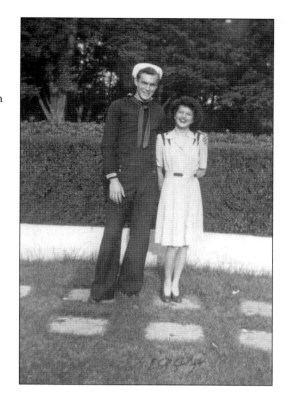

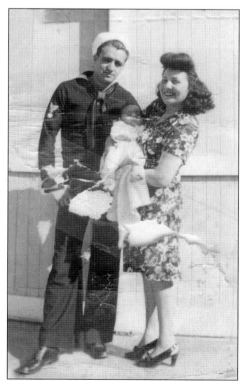

In 1944, Sal Cresci enjoys his leave by spending time with his wife, Rose, and his newborn son Tom. This photograph was taken on the corner of India and Juniper Streets. (Courtesy of the Cresci family.)

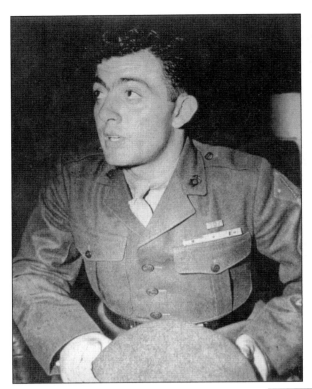

Among San Diego's decorated servicemen stands Gunnery Sgt. John Basilone, a marine who served at Camp Pendleton in Oceanside. In 1943, Basilone was the first Italian American marine in World War II to receive the distinguished Congressional Medal of Honor. (Courtesy of the Command Museum, Marine Corps Recruit Depot San Diego.)

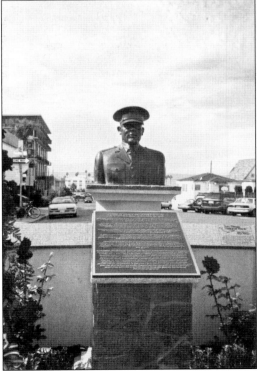

In current revitalized Little Italy, a new piazza, Piazza Basilone, commemorates a fallen hero, as well as the memory of the Italian boys who went to war. Basilone was killed in action at Iwo Jima in 1945. (Courtesy of the Cresci family.)

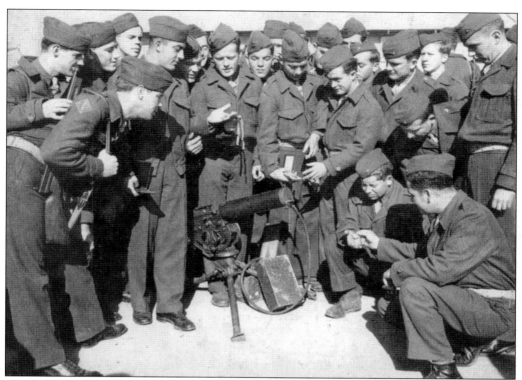

Congressional Medal of Honor recipient John Basilone proudly shares his award with his fellow marines of the 1st Marine Division. The group gathers tightly around a .30-caliber machine gun. (Courtesy of the Command Museum, Marine Corps Recruit Depot San Diego.)

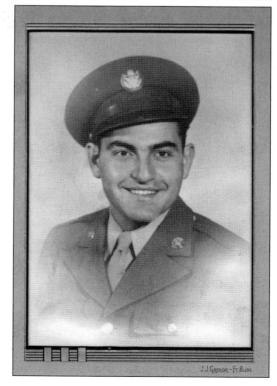

Whereas Sergeant Basilone has achieved renown in San Diego, especially because of the new piazza in his honor, nameless other Italian Americans served the United States in the armed forces. One such resident, John Cicalo, is representative of this commitment. In 1945, Cicalo served as corporal and as assistant to the chaplain, traversing numerous cities to assist with church services. (Courtesy of the Cicalo family.)

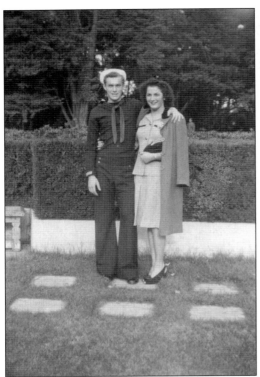

Another typical wartime image captured in 1944 in Balboa Park conveys the bond that Italian colony residents made with the servicemen and women. (Courtesy of Fran Marline Stephenson.)

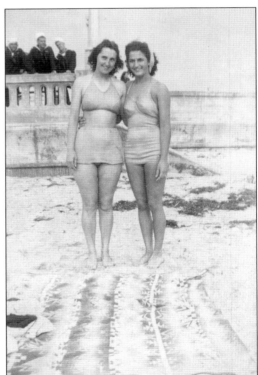

As the war comes to an end in 1945, two young women pose for a photograph in Mission Beach, while a group of young sailors sneak a peek. (Courtesy of Fran Marline Stephenson.)

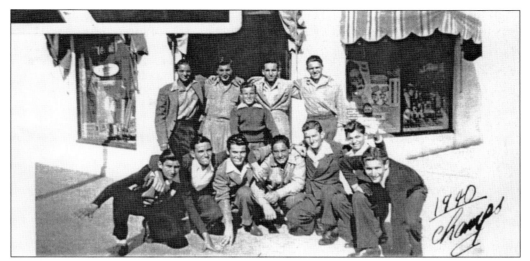

The "Wharf Rats" was the nickname of a close-knit group of teenage boys who gathered outside the Bay City Drug Store in the 1940s. The group shows how young Italians in the colony managed to forge Italian traditions (gathering in a public space to enforce shared community) with American culture (joining the teenage fad of gathering at the local soda fountain). (Courtesy of the Cresci family.)

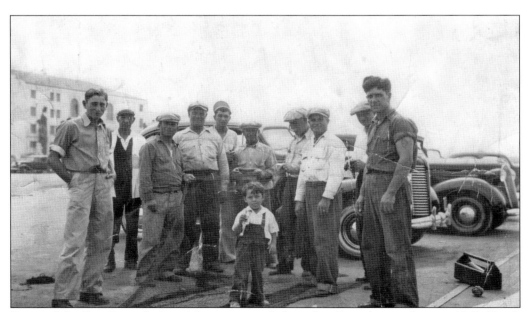

Some of the San Diego Italian fishermen stand along San Diego's waterfront c. 1940. Frank D'Acquisto (right) is the uncle of Major League Baseball player John D'Acquisto, who was a pitcher in the late 1970s for the San Diego Padres. (Courtesy of Mary Balistreri.)

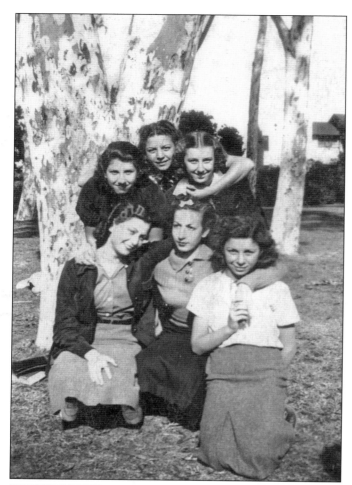

Analogous to the Wharf Rats, this group of young women exemplifies the importance of social groups to the women of the neighborhood. One such all-female group during the 1940s was known as the Chit Chat Club. (Courtesy of Fran Marline Stephenson.)

When the Italian boys pictured here went off to war, their individual photographs were hung on the drugstore walls to commemorate their service. (Courtesy of the Cresci family.)

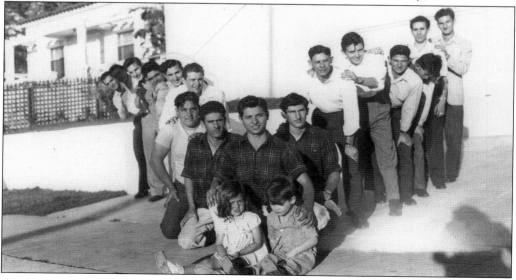

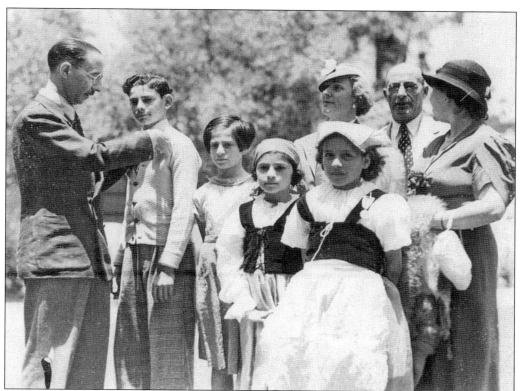

In 1935, at the House of Italy in Balboa Park, the Italian consul general of Los Angeles awards scholarship certificates to students. (Courtesy of the Motisi family.)

Italian-American Woman of the Year -1972

ANNA MOTISI

881 Murray Drive - El Cajon, California 92020 - Phone: 466-3333

This program showcases Anna Motisi, who was the recipient of the Italian American Woman of the Year award in 1972, for her invaluable community work and her influence in the Italian neighborhood. (Courtesy of the Motisi family.)

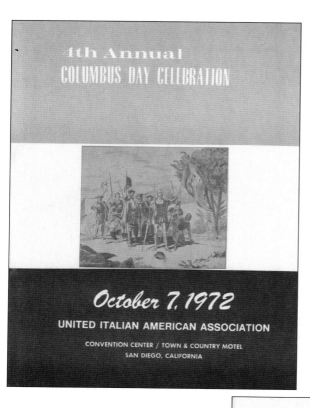

4th Annual
COLUMBUS DAY CELEBRATION

October 7, 1972

UNITED ITALIAN AMERICAN ASSOCIATION

CONVENTION CENTER / TOWN & COUNTRY MOTEL
SAN DIEGO, CALIFORNIA

This is the program for the Fourth Annual Columbus Day Celebration in 1972, held by the long-standing United Italian American Association. This organization has been the force in organizing Columbus Day parades for many decades. The program insert for the celebration offers a glimpse of the festivities and reveals some honored guest attendees. (Courtesy of the Motisi family.)

program

General Chairman	Michael DeStout
Toastmaster	Phil Motisi
Pledge of Allegiance	Sam Brunetto
Invocation	Fr. Paul Marconi
Welcome	Michael DeStout
Comments	Honored Guests
Award Presentations	Michael DeStout
Italian-American of the Year	Anna Motisi
Queen — United Italian-American Association	Sarah Sardina
Mazara Del Vallo Parade Float	Vito Ferrentello
Music	L & M Orchestra

HONORED GUESTS

Hon. & Mrs. Pete Wilson — Mayor, City of San Diego
Hon. & Mrs. Joseph Alioto — Mayor, City of San Francisco
Mr. & Mrs. Frankie Laine — Parade Marshal
Mr. & Mrs. Frank Curran — Former Mayor of San Diego (retired)
Miss Gretchen Early — Central City Association
Mr. & Mrs. Ray Lubach — Central City Association
Mr. & Mrs. R. L. Hoobler — Police Chief, City of San Diego
Mrs. Anna Motisi — Italian-American of the Year
Dr. & Mrs. Gino Jannone — Italian Vice Consul
Rev. Fr. Paul Marconi — Honorary Chairman
Rev. Fr. Vincent Posillico — Our Lady of Rosary Church
Miss Sarah Sardina — Queen, United Italian-American Association

Seen here is the cover from the program for the 1956 Italian Fair hosted by Our Lady of the Rosary Parish. The parish held many social events to engage its parishioners in Italian culture and heritage. (Courtesy of Our Lady of the Rosary Parish.)

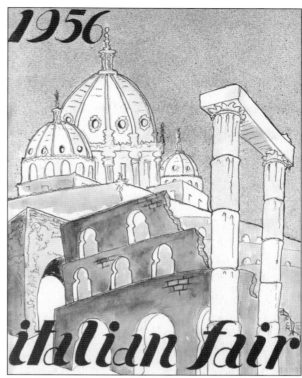

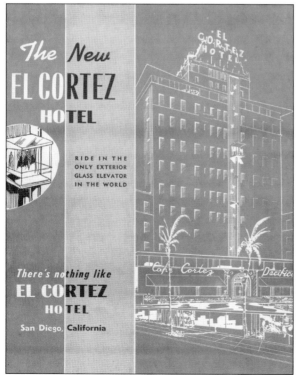

The back cover of the program for the 1956 Italian Fair hosted by Our Lady of the Rosary Parish shows the "new" El Cortez Hotel, which has been a famous San Diego landmark since its opening in 1927. Today the hotel has been redeveloped as a condominium complex, but its allure still remains. (Courtesy of Our Lady of the Rosary Parish.)

Mario Cefalu stands next to Bernadette Tarantino in this contemporary photograph of the annual Festivale Siciliano, or Sicilian Festival, in Little Italy. Cefalu founded the festival in 1993 and was the owner of Solunto Bakery on India Street. Sadly, he passed away in 2007. Tarantino coordinates the current festival, along with Giovanna di Bona of the Roman Holiday Ensemble, ensuring that this tradition continues. (Courtesy of Giovanna di Bona.)

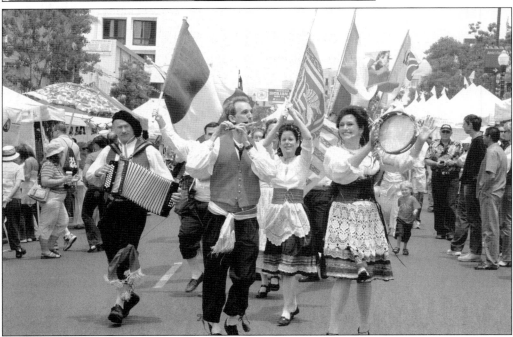

San Diego's Roman Holiday Ensemble, a musical tradition at the Little Italy festivals for the past 15 years, leads a flag procession along India Street as part of the 2006 Sicilian Festival. (Courtesy of Giovanna di Bona.)

124

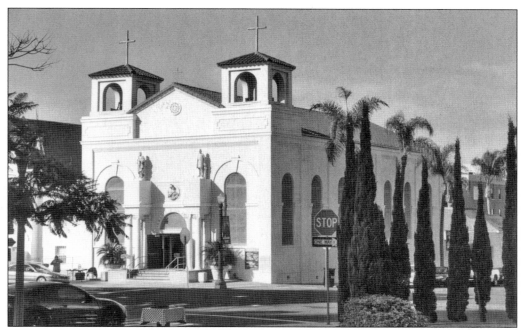

The exterior of Our Lady of the Rosary Parish on State and Date Streets, seen today in revitalized Little Italy, characterizes its beauty and stature in the community. (Courtesy of Nigel Quinney.)

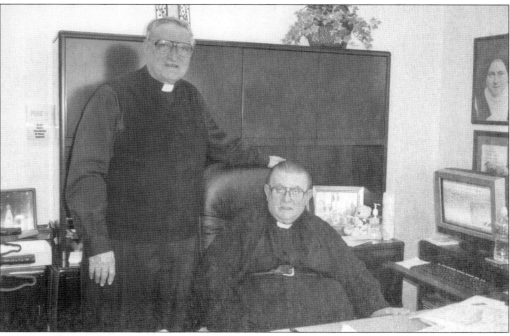

Fr. Louis Solcia (left) and Fr. Steve Grancini are the current pastors of Our Lady of the Rosary Parish. For many years, they have provided support and guidance to the community and have remained important leaders—both spiritually and socially—for Little Italy. (Courtesy of Our Lady of the Rosary Parish.)

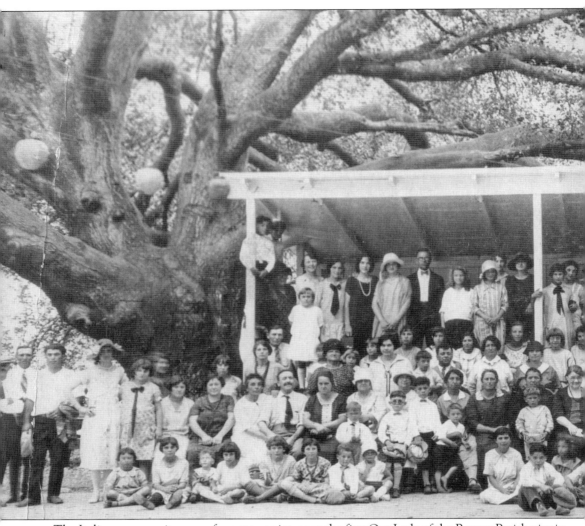

The Italian community poses for a group picture at the first Our Lady of the Rosary Parish picnic

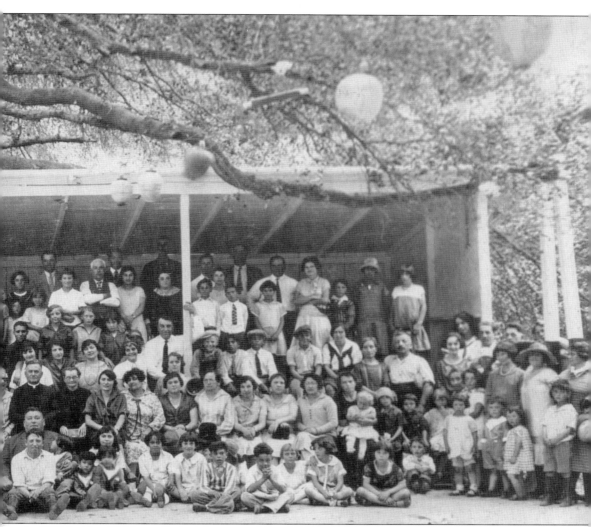

in 1927, held at El Monte Park. (Courtesy of Our Lady of the Rosary Parish.)

ACROSS AMERICA, PEOPLE ARE DISCOVERING SOMETHING WONDERFUL. *THEIR HERITAGE.*

Arcadia Publishing is the leading local history publisher in the United States. With more than 3,000 titles in print and hundreds of new titles released every year, Arcadia has extensive specialized experience chronicling the history of communities and celebrating America's hidden stories, bringing to life the people, places, and events from the past. To discover the history of other communities across the nation, please visit:

www.arcadiapublishing.com

Customized search tools allow you to find regional history books about the town where you grew up, the cities where your friends and family live, the town where your parents met, or even that retirement spot you've been dreaming about.